Ukadia John Goto

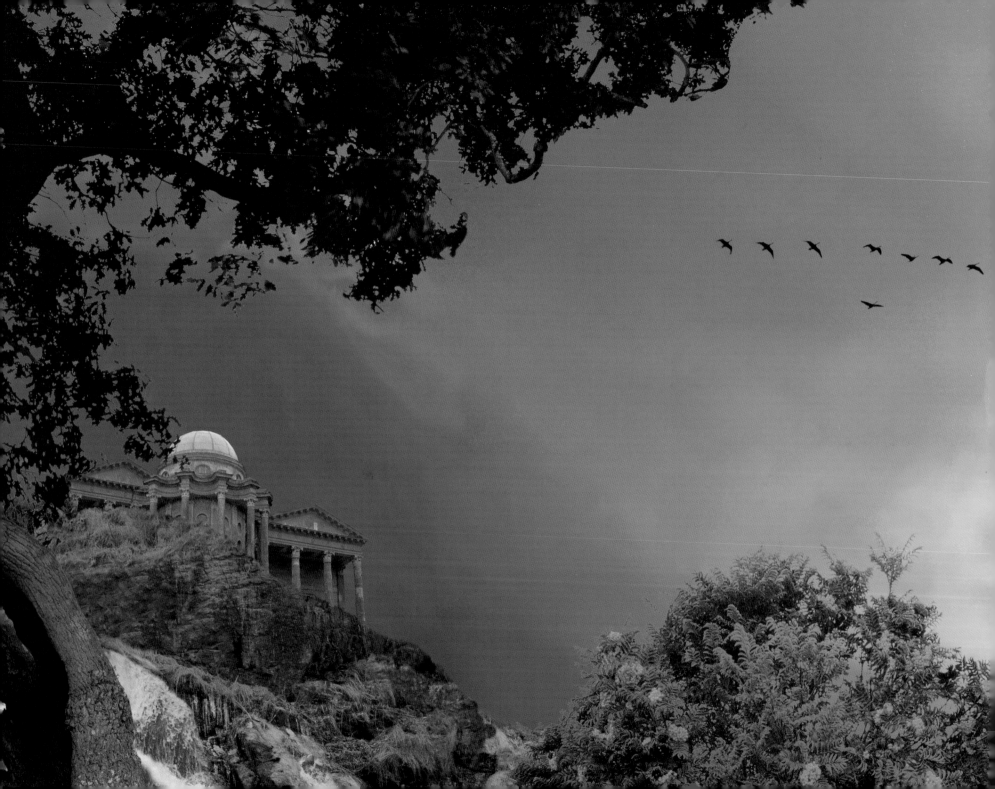

previous page
Pasturelands (detail)

Index of Contents

The Authors

Robert Clark is an artist and writer. Versions of his most recent installation *The Nether Edge Story* have been staged in Oporto, New York and Bruges. He writes regularly for publications ranging from the UK national newspaper *The Guardian* to the international experimental music magazine *The Wire*. He is Senior Lecturer in Fine Art at the University of Derby and is visiting lecturer at a number of European universities.

Dr Mark Durden is Reader in History and Theory of Photography at the University of Derby. He is currently completing a book *From Modernism to the Real: Photography Theory and Practice*, and has written numerous articles on photography. He is also part of the artists' group *Common Culture*.

Dr Charles Saumarez Smith is Director of the National Gallery, London. He was appointed in July 2002, having previously been Director of the National Portrait Gallery from 1994. While at the National Portrait Gallery, he was responsible for commissioning a set of major art works from John Goto.

For further information on the artist visit – www.johngoto.org.uk

Acknowledgements

The artist and Andrew Mummery Gallery would like to thank for their support and assistance The Arts and Humanities Research Board (AHRB), Arts Council South East, University of Derby, Year of the Artist, National Trust, National Portrait Gallery and British Council. They appreciated the good advice of Professor David Manley, Director Designate of the School of Arts, Design & Technology at the University of Derby and Keiren Phelan, Literature Officer at Arts Council South East. They would like to express their gratitude to the authors Robert Clark, Mark Durden and Charles Saumarez Smith and also extend their thanks to Michael Young for his soundscape to *Capital Arcade* and Paul Dibley for website design. They are particularly indebted to all the people who have modelled for the pictures.

For their involvement in previously exhibiting or publishing works from these series they would like to thank Gloria Chalmers at *Portfolio*, Edinburgh; Walt Warrilow at Howard Gardens Gallery, Cardiff; Wim Melis at Photofestival Noorderlicht, Groningen; Anibal Lemos at ImagoLucis Galeria, Oporto; Les Buckingham and Joanne Bushnell at Aspex Gallery, Portsmouth; Marguerite Nugent at Wolverhampton Art Gallery; Christopher Woodward at the Holburne Museum, Bath, with the support of Daniel Hinchcliffe at the University of Bath and Malcolm Miles at the University of Plymouth; Kyung He Hwang at Seonam Arts Centre, Seoul; Anne de Charmant at Meadow Gallery, Burford House, Tenbury Wells; Andrew Hunter at Gainsborough's House, Sudbury; Val Williams at The Hasselblad Center, Goteborg; Fiona Venables at Tullie House Museum and Art Gallery, Carlisle; Andreas Müller-Pohle at *European Photography*, Göttingen; Alison Plumridge at the Art Gallery & Museum, Royal Leamington Spa; Thomas Seelig at Fotomuseum, Winterthur; Kathy Fawcett at The City Gallery, Leicester; Frits Gierstberg at Netherlands Fotoinstituut, Rotterdam; Susan Zadeh at *Free-Eye*, Amsterdam, and Alistair Hicks at the Deutsche Bank Collection, London.

They gratefully acknowledge the contribution to the *Ukadia* exhibition and publication of Joanne Wright, the staff of the Djanogly Art Gallery and David Bickerstaff. Finally they would like to thank Neil Walker, Visual Arts Officer at the Djanogly Art Gallery, for his enthusiasm, good humour and curatorial skill in nurturing this project.

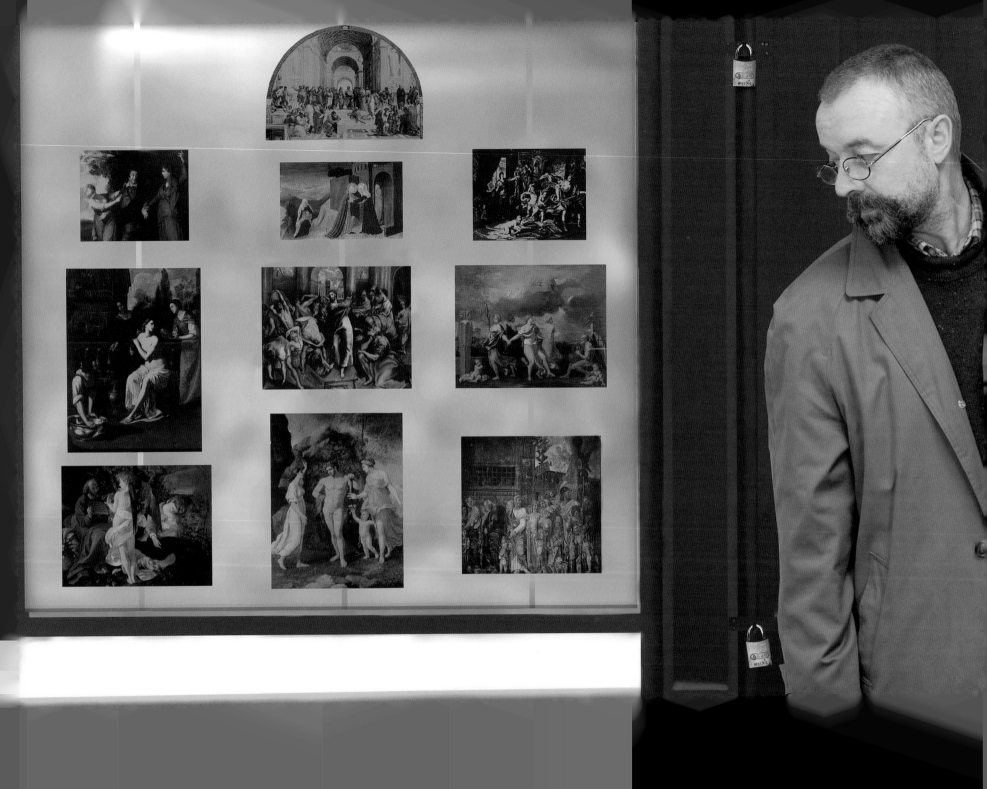

Foreword

Neil Walker
Visual Arts Officer, Djanogly Art Gallery

The Djanogly Art Gallery has established its reputation on the presentation of both contemporary art and of the art of the past, and it is therefore perhaps not surprising that when approached by John Goto and the Andrew Mummery Gallery with a view to staging an exhibition of John's recent work we jumped at the opportunity.

John's photographic compositions are heavily laden with allusions to art historical precedents: to the arcadian idyll of seventeenth-century landscape painting, the English landscaped gardens at Stowe, Rousham and Stourhead; and the lofty rhetoric of academic history painting. His modern 'histories' which ruefully reflect upon a state of political disillusionment in contemporary Britain belong to a peculiarly English tradition of social satire with its roots in the eighteenth century and particularly in the work of William Hogarth. Conversely, in the early 1990s, the artist in his exploration of a new pictorial language, was an early pioneer in the use of photo-digital technology and it is his intelligent use of this new medium which imbues his work with such a contemporary sensibility despite its indebtedness to the artistic vocabulary of the past.

This publication and the exhibition it accompanies brings together three series of related works begun in 1997 and completed in 2003 – *Capital Arcade*, *High Summer*, and *Gilt City*. The latter, which is the most recent, is being exhibited at the Djanogly Art Gallery for the first time. The common thread running through all these works is a preoccupation with issues - social and political - current in British society today: the compromising effects of consumerism, our troubled relationship with the countryside and rural life and the yawning divisions between the 'haves' and 'have nots' under a socialist government. The title of the exhibition is itself the artist's wry rebranding of a cherished national self-image inherited from our mythical past.

Several organisations and individuals have contributed to the success of this project and whilst many of them are acknowledged elsewhere I would like to express our particular gratitude to Arts Council South East, the Arts and Humanities Research Board (AHRB) and the University of Derby for their generous funding of the production costs of the exhibition and this publication. Three eminent commentators on current art practice – Robert Clark, Mark Durden and Charles Saumarez Smith - have contributed essays to accompany John's photographs which are sure to enrich the reader's understanding of the artist's work. Finally, I would like to give my special thanks to John both for the fertility of imagination and execution evident in this body of assembled work and for his commitment to bringing the project to fruition at the Djanogly Art Gallery.

Unit 9 Capital Arcade (detail)

John Goto: an appreciation

Charles Saumarez Smith
Director, National Gallery

Man and Child, Turkey 1971

I first came across the work of John Goto in an exhibition held at the Mall Galleries in 1998, when I saw for the first time the photographs he had taken in Istanbul in the early 1970s. I was looking for a photographer to document the forthcoming building project at the National Portrait Gallery. I was conscious that the standard conventions of architectural photography, particularly of new buildings, tends to be bland, without strong effects of atmosphere or lighting, as if the buildings were never intended to be inhabited. Here, in Goto's work,

I found the style of architectural photography I was seeking. It belongs to a tradition which goes back to Eugene Atget whereby buildings appear as the sediment of past activity, holding in their details the impress of previous generations who have lived in and used them, the marks of weather, poverty and time. His photographs demonstrated how buildings are subject to changes in use, rather than being simply documents of abstract form. So, I must have somehow got in touch with Goto, perhaps through his friend, Arturo di Stefano, who shares the same aesthetic, fractured and tentative, about palimpsests and sgraffito.

We commissioned Goto to take the photographs for a book about the National Portrait Gallery and he became nearly photographer-in-residence, documenting the transformation of a traditional late Victorian public institution by the addition of its new Ondaatje Wing. He became a characteristic feature of the building project with his tweed suits and big moustache and Russian panoramic camera which distorted every line into an illusion, much to the irritation of the architects, Jeremy Dixon and Edward Jones, who wanted a more conventionally modernist record.

The book which was the result of this project has been perhaps inadequately appreciated for the quality of its photographs, including double page

spreads of a man feeding the pigeons in Trafalgar Square and of the east façade of the National Portrait Gallery in the early morning sun, of John himself standing in one of the top floor galleries before its redecoration admiring Roubiliac's bust of Hogarth and Arturo di Stefano standing in front of his portrait of Richard Doll, minor jokes which would escape even the most attentive reader, but which add to the sense of layers of use and meaning and surprise in an old public building where the encounter between the building and its public is at least as important as the strict record of the interiors. Goto infused his photographs with precisely the character I wanted them to have, showing the life of the institution and what happened behind the scenes, the unpeeling of its moods, in a way which is comparable, but drier and more ironic than the work of Thomas Struth.

Quite soon after Goto had embarked on the task of documenting the buildings of the National Portrait Gallery, I discovered that I had deflected him from pursuing his other work, which at the time consisted of the large, surreal digital collages exhibited at the Andrew Mummery Gallery as *Capital Arcade* in early 2000. So, I suggested that he might like to portray the groups involved in the construction of the Ondaatje Wing: first, the Donors who were assembled digitally in the old Tudor Gallery; next, the Trustees in the Regency Gallery; then the staff in

the picture store at the end of the Northern Line in Merton; and, finally, the construction workers, who were the heroes of the project. For a while, these large digital collages hung close to the entrance of the National Portrait Gallery, until one of the Trustees noticed that his image had been digitally reversed and complained that the picture was a misrepresentation.

But, the whole point of Goto's work is precisely that he plays with drama and irony and illusion, seeking to use the latest technology to indicate the decay of past traditions, so that the Pantheon beyond the lake at Stourhead is shown with a helicopter circling overhead. There are figures dressed as for a nuclear attack in the field; classicism is combined with ruins; the army has come to Rousham; and the landscape of the picturesque and of Claude Lorrain is used for shooting.

I am not quite sure what to make of these images. They are simultaneously technically ingenious and metaphysically gloomy. But, as with the photographs of Istanbul from the early 1970s, one can feel Goto playing with the revelation of history, the relationship between image and meaning, in ways which are wilfully provocative and lie outside the norms of much contemporary image-making.

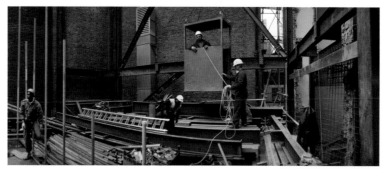

Docking, 1999
© National Potrait Gallery, London

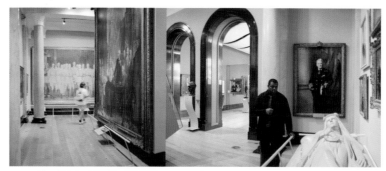

Isaac Julien beside an Effigy of T.E. Lawrence, 1999
© National Potrait Gallery, London

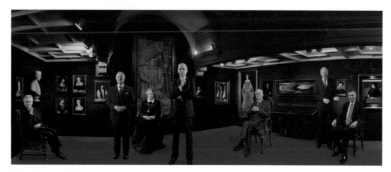

The Donors, 1999
© National Potrait Gallery, London

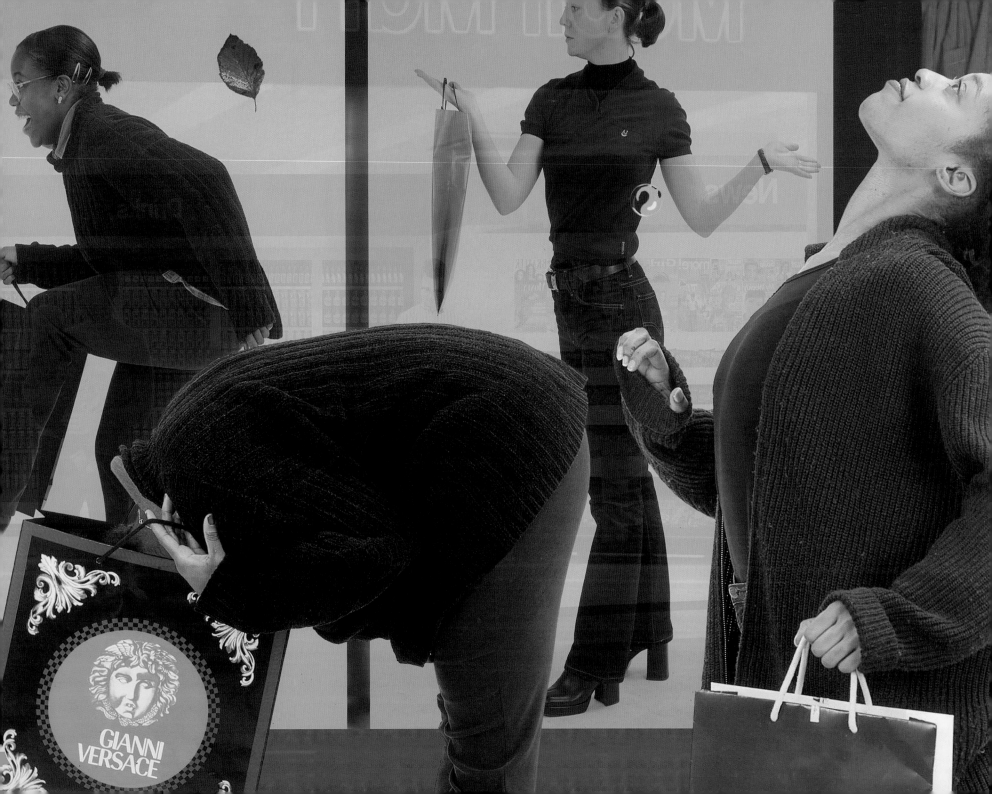

Capital Arcade

previous page
Unit 4 Capital Arcade (detail)

opposite
Welcome to Capital Arcade

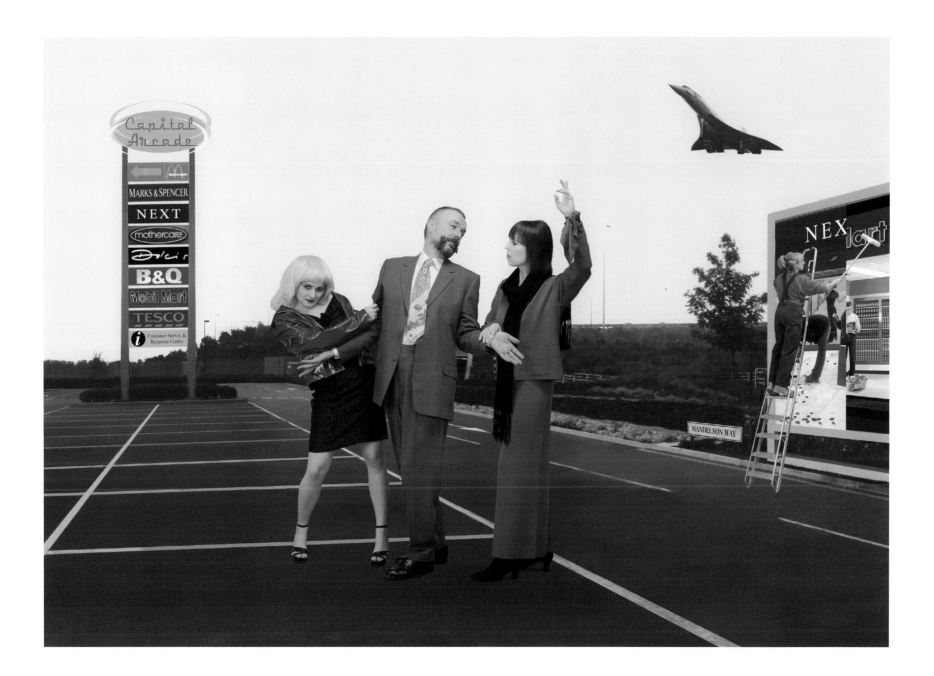

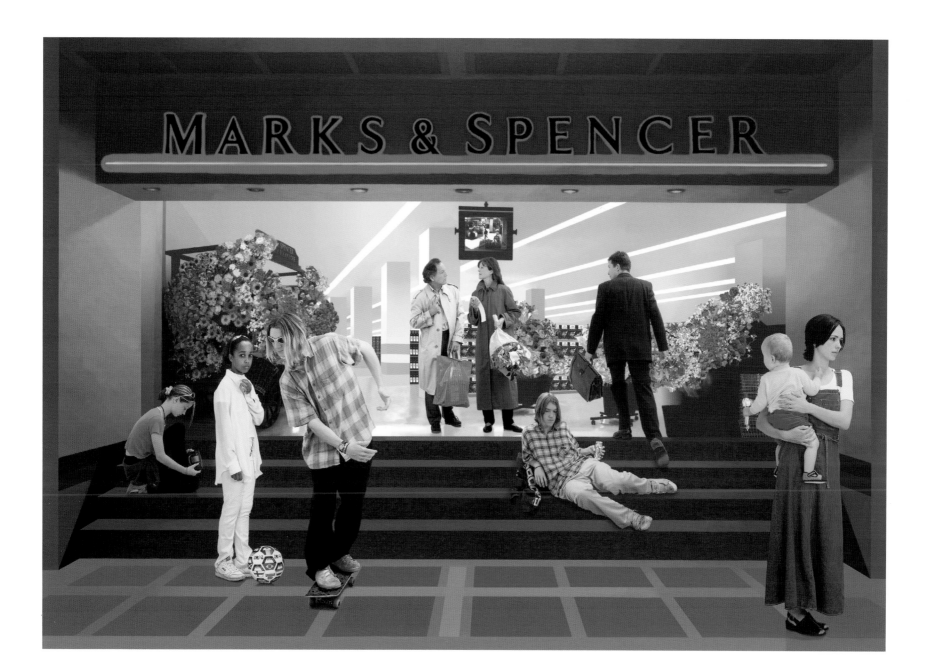

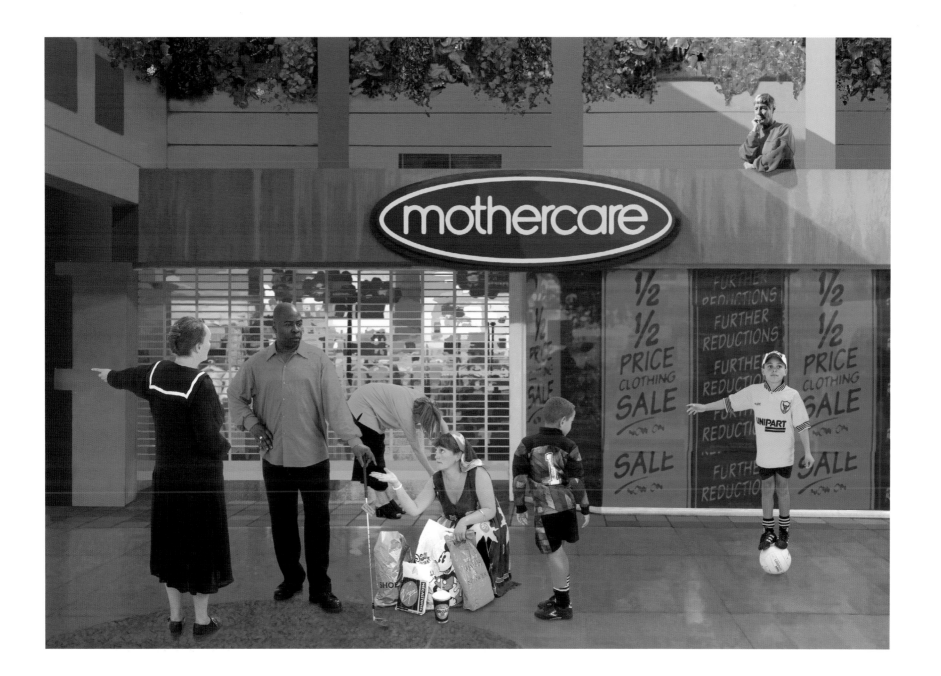

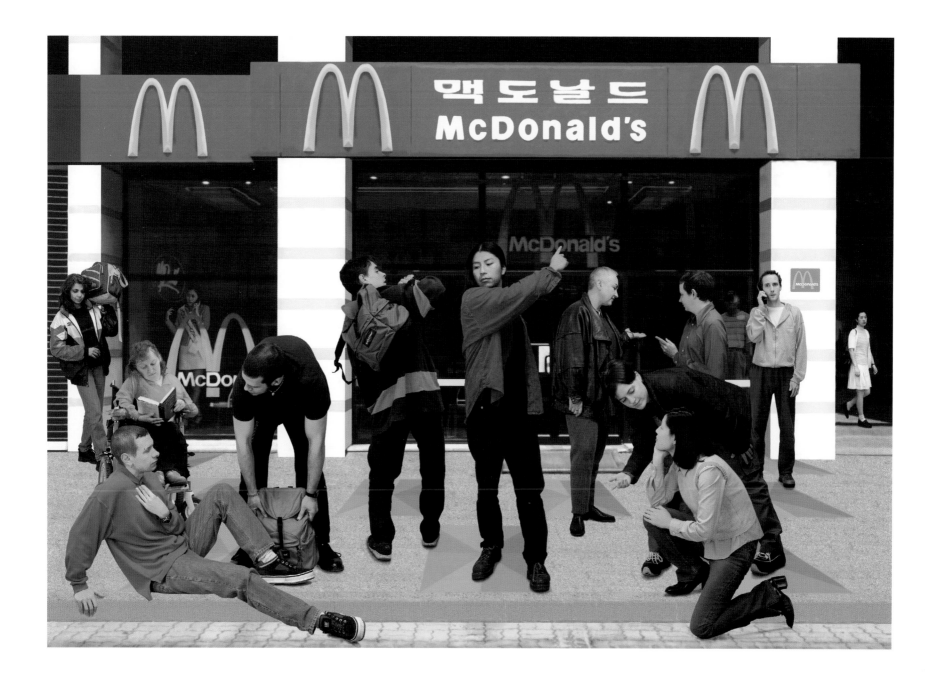

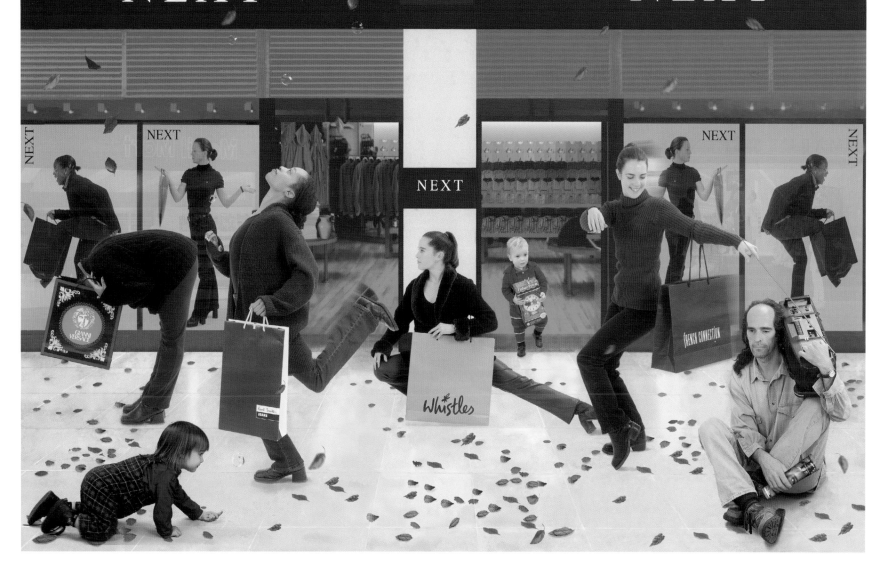

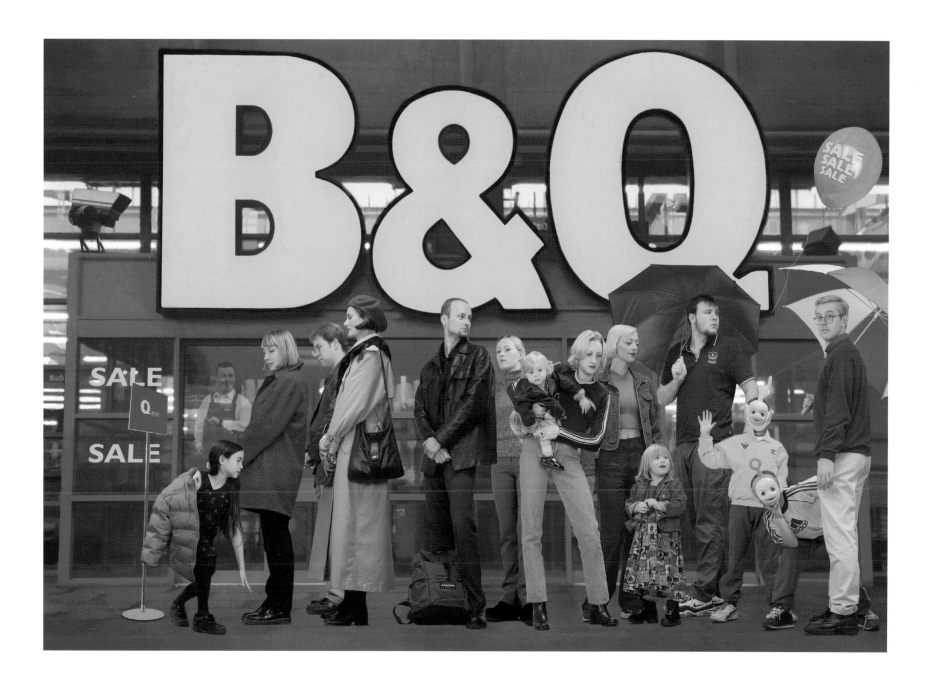

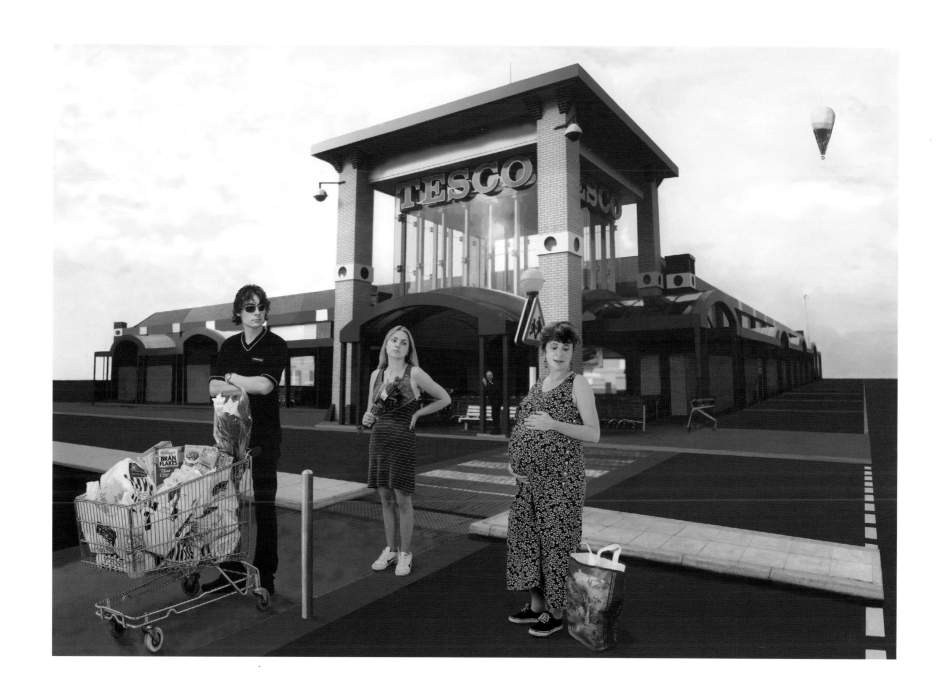

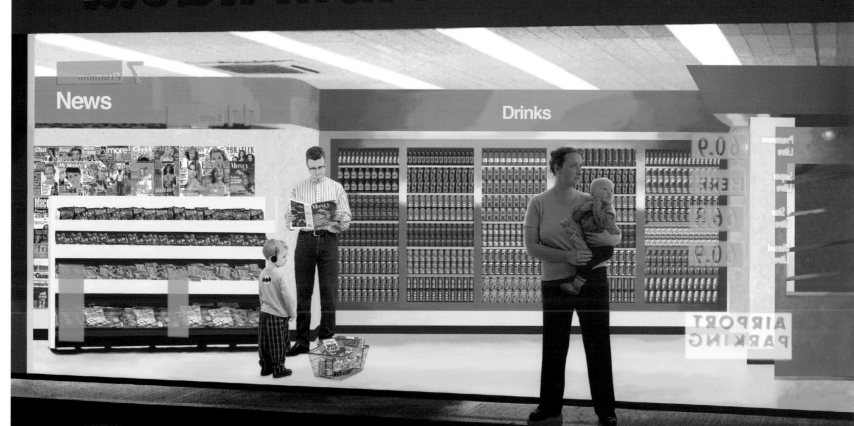

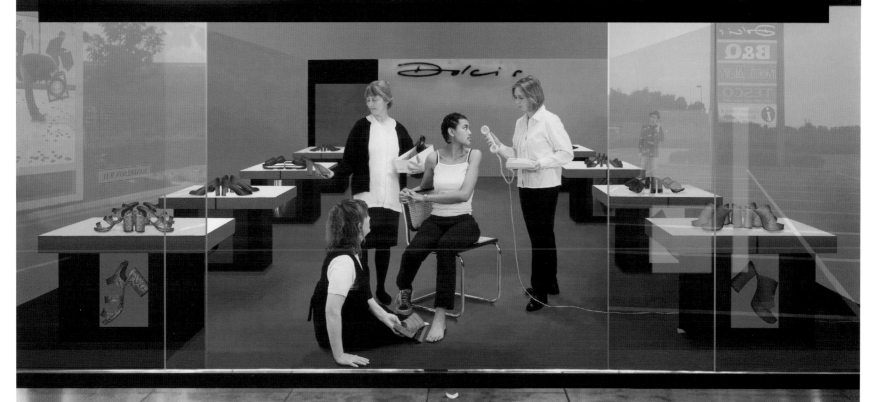

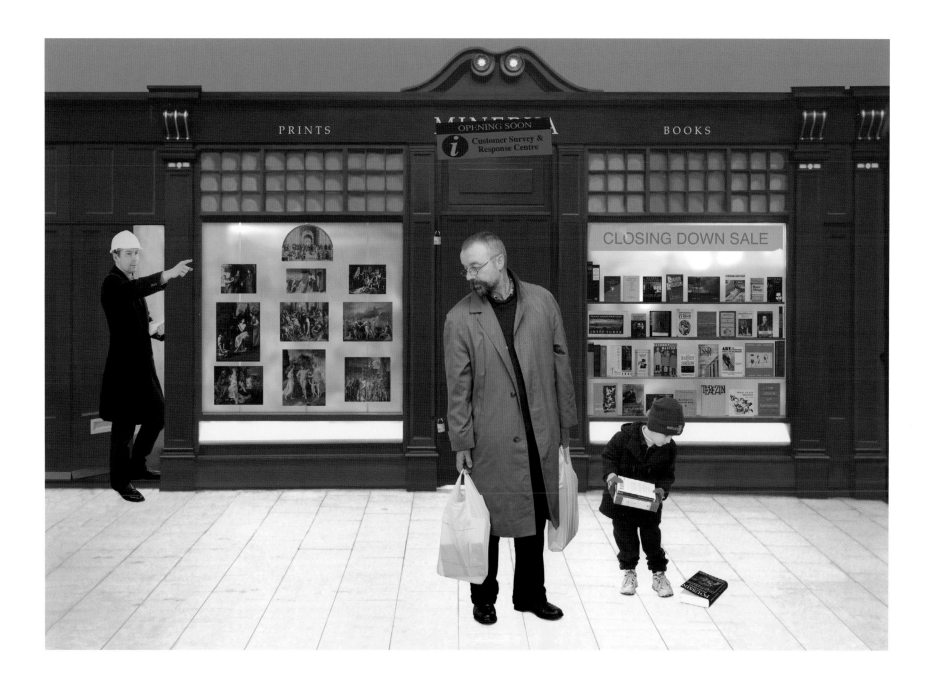

John Goto:
Capital Arcade and High Summer*

Robert Clark

The spatial landscape might appear to be expanding but the temporal perspective is shrinking alarmingly. As communications media afford easy access to even the most obscure geographies of the global village and the façade of otherness becomes readily available at the click of a mouse, the disembodied information and imagery thus accessed appears to exist always and forever in a virtual present. Despite history being arbitrarily revived and plundered, the significant memory of the increasingly absent minded contemporary artist extends back no further than the 1950s and 60s.

These are, of course, massive generalisations but they reflect trends against which the highly individual artist John Goto stands out in distinctive opposition. Goto is no reactionary traditionalist. He has embraced digital technology with an avid curiosity and rare expertise. Yet his digital illusions are creatively, atmospherically and intellectually deepened by an incisive engagement with the selective perspectives and retrospective illusions of history. Goto's photo-tableaux are heavily based on painting. It is not often recognised to what an extent our world of appearances continues to be conditioned by the history of painting. Several centuries of post-Renaissance Western painting have deeply impressed our collective creative consciousness with perceptual and compositional templates that still form the basic visual vocabularies

of the photographer, film-maker and video artist. Goto is one of the few artists around who works with a full and sensitive awareness of this fact. He has also worked extensively with political history and the politics of history, reflecting, for instance, on the final years of Kasimir Malevitch's life in Stalinist Russia (*The Commissar of Space*, 1995) and the internment of a Bauhaus trained artist in the Jewish Ghetto of Terezin (*Terezin*, 1988).

More recently, with *Capital Arcade* in 1999, Goto presented a digital theatre of consumer absurdity as the first section of a new series of visual reflections on contemporary life. The artist has stated that the more overt satirical and comedic intentions of this new series was a direct response to the vacuum left by the collapse of socialism. Typically, however, the satirical thrust of *Capital Arcade*, with its enraged parodying of post-socialist New Labour managerial and consumerist society, is set against constant references to historical visions of human potential that surely ran deeper, were more potent, more celebratory, more life enhancing. In a series that appears, in its spirit of amused and alarmed disgust, to be reminiscent of such pre-socialist subversive models as the satires of Hogarth or Goya's *Caprichos*, Goto makes precisely coded compositional references to a history of image making ranging from the 15th century canvases of Andrea Mantegna through to an 18th century allegorical portrait painting by Joshua

Reynolds. It is a measure of his almost unique standing amongst his British artist contemporaries that the digital photo-artist Goto can be seen as a non-traditional genre and history painter, in the traditional sense of these terms, whose work it is impossible to discuss without constant references to art history.

Goto sets the scene in the Capital Arcade car park, just off Mandelson Way, with an image based on Reynolds' *Garrick Between Tragedy and Comedy*. The self-mocking artist casts himself as the infamous actor David Garrick, whose ability to command both comic and tragic roles was, as a writer of his day wrote, 'clearly destined to dispel the barbarianism of a tasteless age'[1]. The besuited artist turns sympathetically towards the sophisticated brunette figure of tragedy, but perhaps the garish tie that he proudly wears betrays his true underlying loyalties and passions. Surely it was bought for him by the peroxide blonde vamp that tugs away at his other arm as Concorde thunders pertly by overhead? In the final image of the series the decidedly dejected artist anti-hero is weighed down by two plastic carrier bags bulging with precious purchases from a Minerva bookshop Closing Down Sale. Works that he was unable to salvage, by the likes of Louis-Ferdinand Céline and Chris Marker, can be glimpsed in one shop window. In the shop's other window are systematically displayed prints of the images on which the entire *Capital Arcade* series is based. The bookshop is being replaced by a Customer Survey and Response Centre. To stage right a young boy struggles to hold onto T. S. Eliot's *Collected Works* and a bulky volume on Poussin - perhaps a final hint of cultural optimism? One could, and can, go on and on decoding these images that are far from hermetic or obscurantist, that open themselves up with increasing intrigues, ironies and insights, in a mood of profound cultural disillusionment and a delight in the equally profoundly affecting creative illusions of art. In between the artist being tempted into the arcade and his final escape, or expulsion, he encounters eight other painstakingly posed and elaborately encoded tableaux. In the Marks and Spencer scene, compositionally based on Raphael's *The School of Athens*, the figures of Aristotle and Plato have been replaced by a couple engaged in a deep discussion about their shopping bill. In another scene, based on El Greco's *Christ driving the Traders from the Temple*, the porch of the Temple of Jerusalem 'den of thieves', has been transformed into the foyer of McDonald's where an oriental Christ figure, his Apostles and the traders themselves all now look equally conventionally trendy in their brand name gear.

Goto's *Capital Arcade* obviously echoes the global spread since the 1980s of the American model of the out-of-town shopping mall invented in the 1950s by

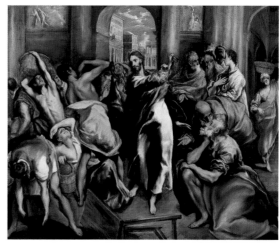

Christ driving the Traders from the Temple c.1600
El Greco
© National Gallery, London

the architect Victor Gruen, who wrote of his brainchild: 'Take 100 acres of ideally shaped flat land. Surround by 500,000 consumers who have no access whatever to any other shopping facilities ...Finish up by decorating with some potted plants, miscellaneous flower beds, a little sculpture, and serve sizzling hot to the consumer.' The artist gives corresponding attention to detail. On the shelves of Goto's Mobil Mart every can and package and mag has been digitally immaculately positioned and delineated. The artistic qualities of these works, their ability to transcend mere illustrational caricature, derives from Goto's lengthy and subtle working methods. Thousands of photographic images taken over the years by the artist serve as an archive from which he can digitally create montages. Having planned a work through drawings and studies, he will also photograph deliberately staged and lit scenes of his carefully posed protagonists. Thus each work becomes a new take on the topical mutually dependent dichotomy between pictorial truth and lies, authenticity and pretence, documentary fact and artful artifice. Goto refuses the simplistic model of the creative process that has become so widespread in contemporary art education, the linear model whereby it is assumed that an artist must first do research to adopt a worthy idea from a respectable theory, then must do the work to test or fulfil the theory, then is obliged to offer up the work to the academic specialists for final expert analysis and interpretation. With Goto the process rather involves an almost simultaneous interbreeding of active perceptions, thoughts, intuitions and technical struggles, of creative darings and self-critical editings, of aesthetic, technical and intellectual involvements.

With the following series in 2001, *High Summer*, this merging of what we might call aesthetic conviction and poetic evocation is perhaps even more convincing. In *High Summer* our relationship to the natural world is focussed through a historical filter that includes the 18th century English gardens at Stowe, Rousham and Stourhead and the 17th century French landscape paintings of Nicolas Poussin and Claude Lorrain. The artist's passionate admiration for both Claude and Poussin is evident throughout *High Summer*. The series' air of poignant enchantment is obviously influenced by his love of two Claude paintings in particular, both of them in the National Gallery in London: *Landscape with Aeneas at Delos* and *Seaport with the Embarkation of Saint Ursula*. The classical architecture of the latter image is directly reflected in *High Summer*, as is the suggestion of a historical narrative of momentous disquiet. Saint Ursula was a British princess who made a pilgrimage to Rome with 11,000 virgin companions who were all promptly martyred on their return to Cologne. Similarly Goto has adapted the significant compositional sophistication of Nicolas Poussin's *Landscape with a Man Killed by a Snake*, also in the National Gallery. Here Poussin cleverly conveys the inexact science of perceptual transference and contagion. One observer flees in terror in seeing the man killed by the snake. A nearby woman throws up her arms in alarm as she sees the man fleeing, but is actually unaware of the snake or its victim. In the background a group of men carry on fishing, blissfully unaware of any unusual happenings at all.

It is also typical of Goto that he has taken a facile trend of contemporary culture - the TV fixation with suburban backyard landscape gardening - and imbued it with revelatory metaphoric and historical significance. A series of digitalised cultural tourists act out their various inherited social conventions in a digitalised 'people's park'. It is immediately evident that, although there might be a pretence of idyllic calm, all is in fact not well in the artificially landscaped heritage garden of contemporary Britain. Goto takes one social faction after another, transports them into a historical perspective of neo-classical grandeur and lets them show themselves up.

Goto's ironic cultural conceits are immaculately realised. The original architects of the Stowe, Rousham and Stourhead gardens were influenced by the Arcadian Italianate landscapes of Claude Lorrain and by observations of classical antiquity made on

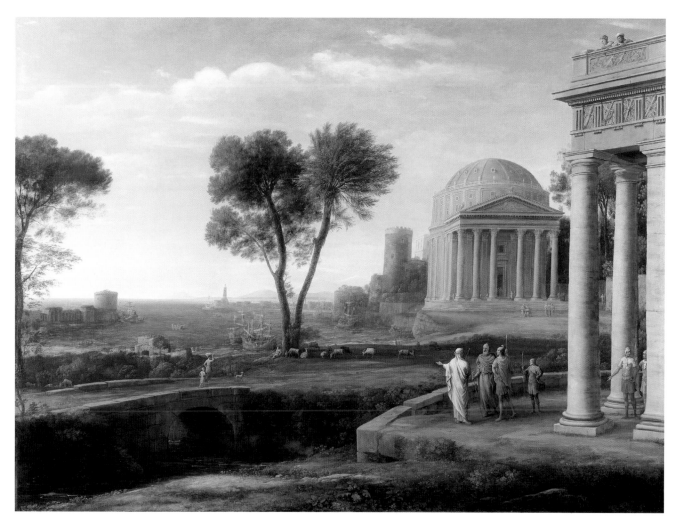

Landscape with Aeneas at Delos 1672

Claude

© National Gallery, London

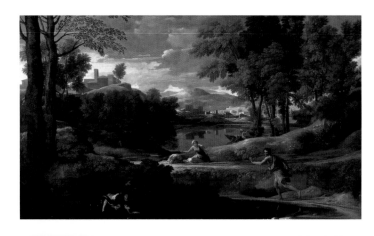

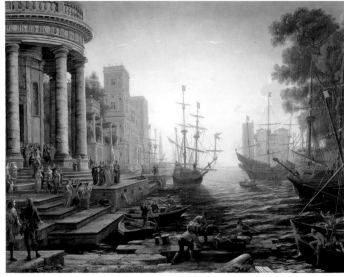

the then obligatory educational trip for the cultural elite, the Grand Tour. Such gardens were laid out in designs that embodied attitudes towards nature and human nature that had political, philosophical and even metaphysical significance. Natural viewpoints were often achieved by cunning artifice. At Rousham the Royal Gardener Charles Bridgeman's most notable innovation was the introduction of a ditch surrounding the garden, instead of a fence or wall. This gave the illusion that the traditional avenues and carefully contrived 'little wildernesses' of the garden were not entirely separate from the surrounding countryside of common fields. The ditch was known as a ha-ha. It was left to the unsuccessful painter William Kent, who succeeded Bridgeman at Rousham, to perfect the organic artifice of the naturalistic landscape. At Stowe he installed Elysian Fields, a River Styx, a Temple of Ancient Virtue containing statues of Socrates and Homer and a Temple of British Worthies containing busts of such Whig heroes as Locke, Bacon, Newton and Milton.

These gardens became fascinating plein-air theatres in which natural and cultural ambiguities and contradictions were enacted with such immense formal sophistication that even the disbelief of the most politically radical doubters was likely to be seduced into suspension. Goto samples views of the gardens and reconstructs them according to compositional principles derived from Claude Lorrain. His various groups of protagonists, often

dwarfed by fake classical ruins, have been sampled from 'real life' situations in present day Britain. His manipulated virtual cultural gatherings are revealingly displaced into the never-never world of the always nostalgic establishment. Goto refers to his setting as a Dyscadia rather than Arcadia. What at first sight appear to be Sunday afternoon recreational scenes, in typically cloudy but far from disastrous British weather conditions, turn out, on closer inspection, to be tragi-comic scenarios of grim cultural disillusionment.

A farmer hangs from a tree; at his feet circular stacks of hay rot and classical columns are stacked, ready no doubt for exporting to America. The myth that the landscape is there to provide us with natural sustenance has finally come to a sick end. The landscaped environment of Britain now plays other roles. Joggers, horse riders, cyclists, hunters and golfers occupy it for their sport. Joyriders use it as a final parking space for their burnt out cars. The army and air force abuse it as a training ground. Eco warriors reclaim it as a symbolic refuge from all that is polluted by technological progress. Refugees from Ascot promenade in their fancy hats along the lake side. Arty types cluster around to discuss a heavily veiled sculpture (whilst, stage right, the artist looks on with a look of wry and dejected resignation). A couple of old winos sleep it off propped against a park bench. A group of actors, looking distinctly uncomfortable in this everyman theatre, pause in rehearsals for a historical confusion of several different period costume dramas. Anoraked muggers do their dirty business in the backwoods. Meanwhile the skies continue to darken and the floods continue to rise.

As in *Capital Arcade* one could view these simply as satires (and the culture of contemporary Britain is surely crying out for some intelligent and cutting satire) if it wasn't for Goto's well trained and highly sophisticated eye for compositional tension, dramatic atmosphere and exquisite variety of formal detail. His modern-day history paintings are often quite beautiful in their realisation of such a doom laden vision. Goto's images embody and demonstrate his ideas rather than literally illustrate them. For a photo-artist who deals with a whole range of issues, he remains refreshingly free from the more stultifying mainstream brands of imported literary theory. Looking at *High Summer* I am further confirmed in my belief that the whole point of the practice of creative experiment is (temporarily) to get rid of the constant need for theory and to prove/disprove, embody/evaporate theory's premise so that it need not be endlessly regurgitated or repeated.

You can of course look at these recent works and interpret them according to the implied metaphoric relationships of the various images. You can also, however, sense these relationships through the relative presence of their forms. The digital pixelation perfectly evokes the hallucinatory feel of a dream theatre. The bland authority of classical columns is complemented by the tired authority of an ancient oak. Through the skies, which are precisely keyed to emotionally specific moods, one can spot flying birds, jet aeroplanes, a helicopter and a kite that stress by contrast the heavy futility of the earthbound goings-on. Through such considered devices Goto's satires are flavoured with a disarming, often semi-humorous affection for the intricacies of nature and the fallibilities of human behaviour. His satires are far from cynical. The all enveloping atmosphere suggests that the man with the lens is in there with the rest of them, wondering what the hell is going on and when on earth it will all end.

*A shorter version of this essay first appeared in *Portfolio, the Catalogue of Contemporary Photography in Britain* No. 33 June 2001.

1 Garrick's contemporary Richard Cumberland quoted in *David Garrick*, Encyclopedia Britannica, Eleventh Edition, Volume XI, Cambridge: University Press 1910 p 475-77.

High Summer

previous page
Deluge (detail)

opposite
Eco Warriors

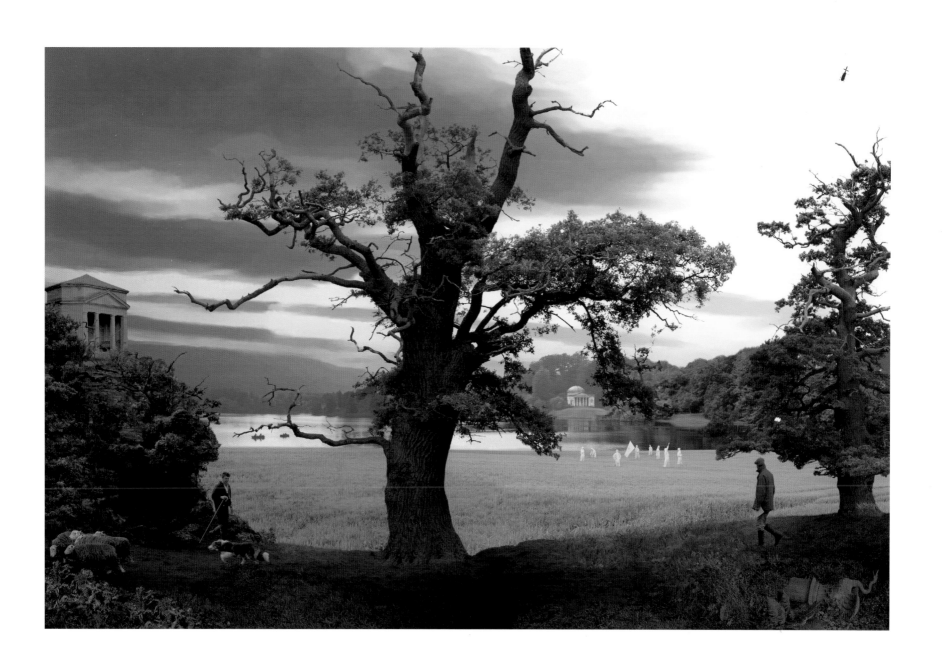

Hunters

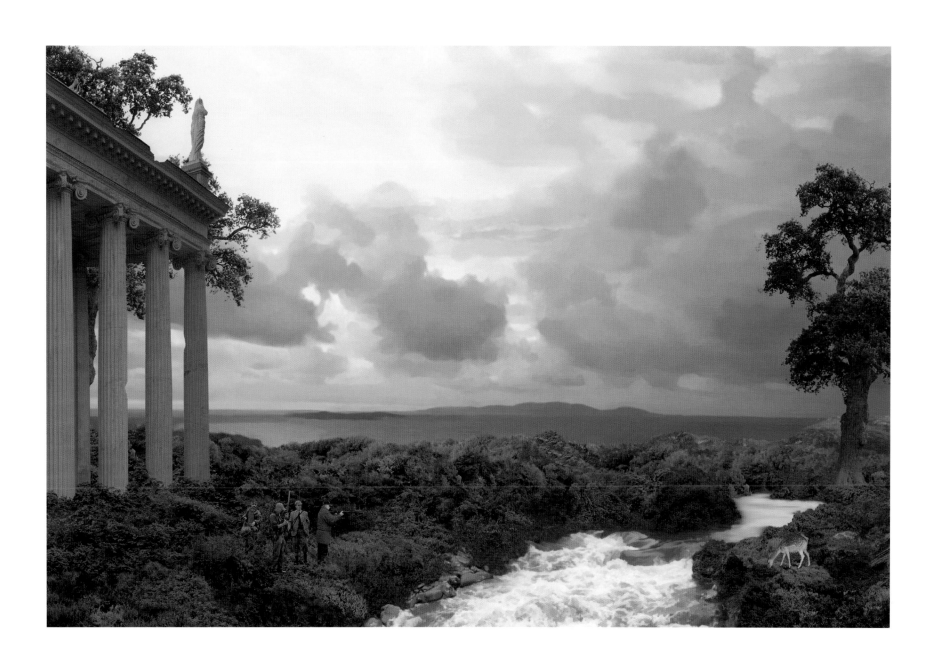

Dancer

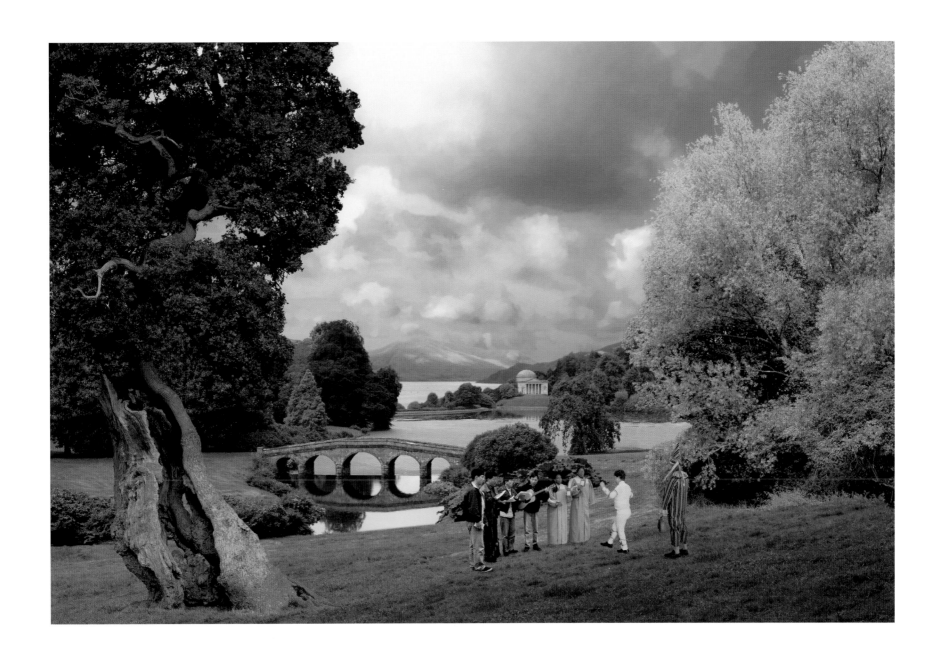

Movie

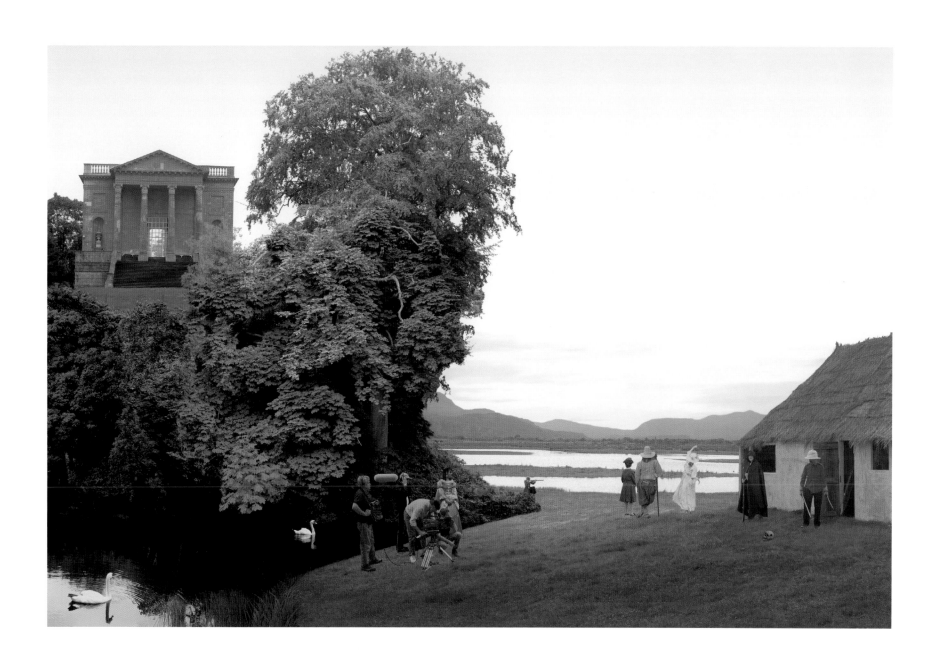

Society

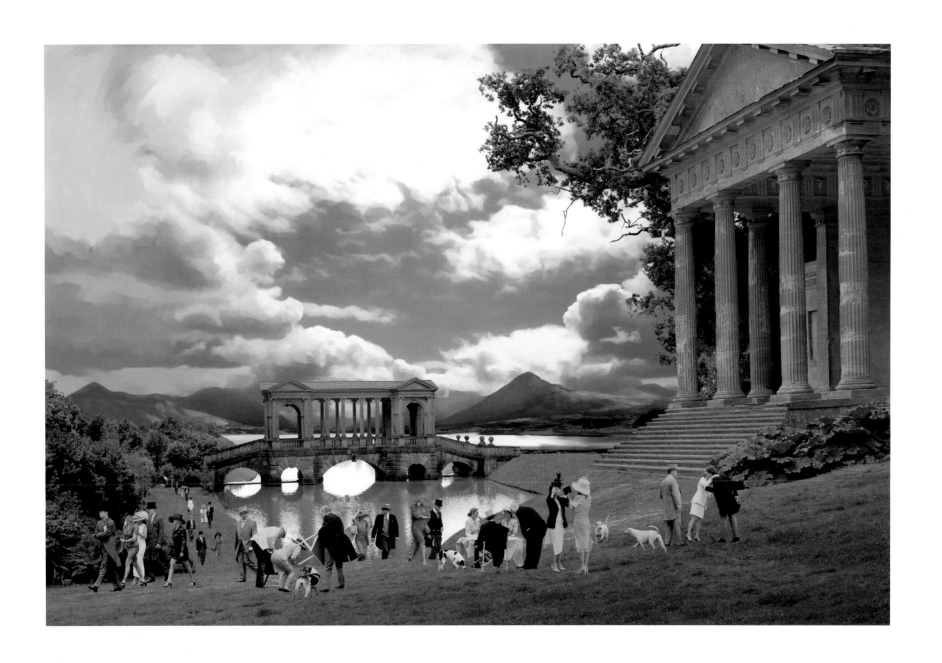

Sporta

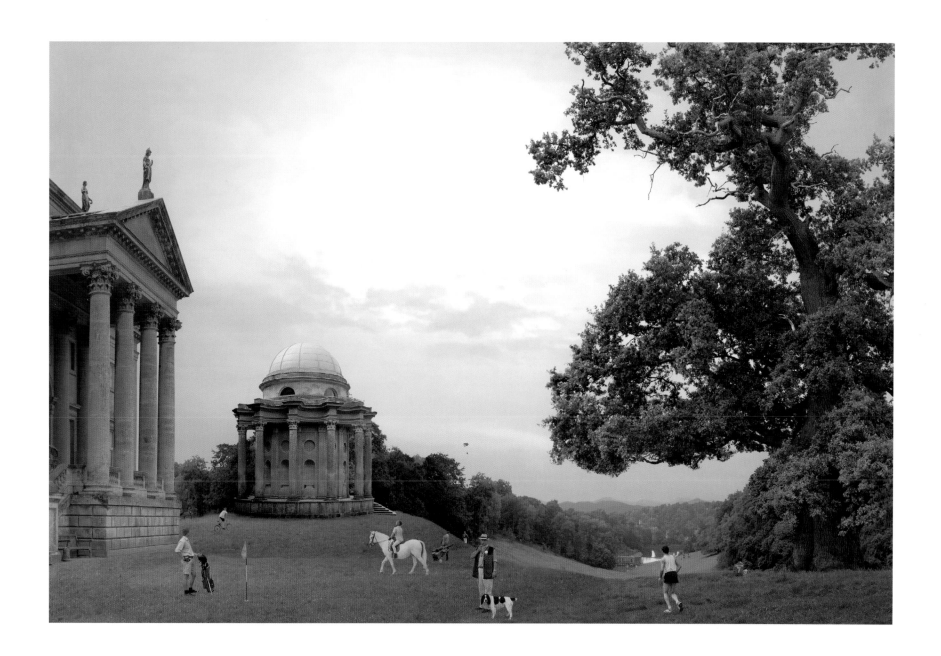

Beach

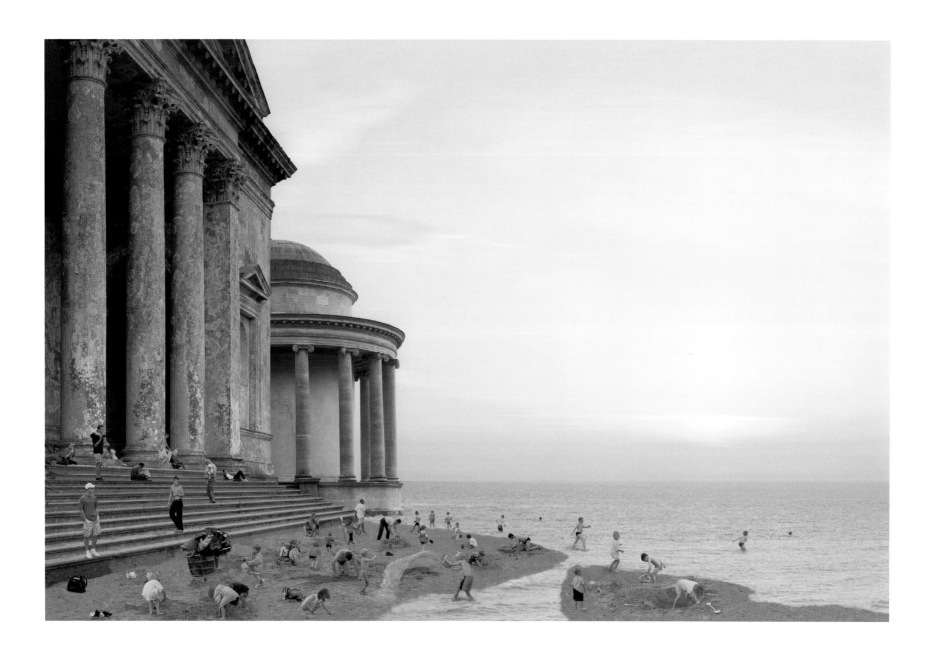

Plinth

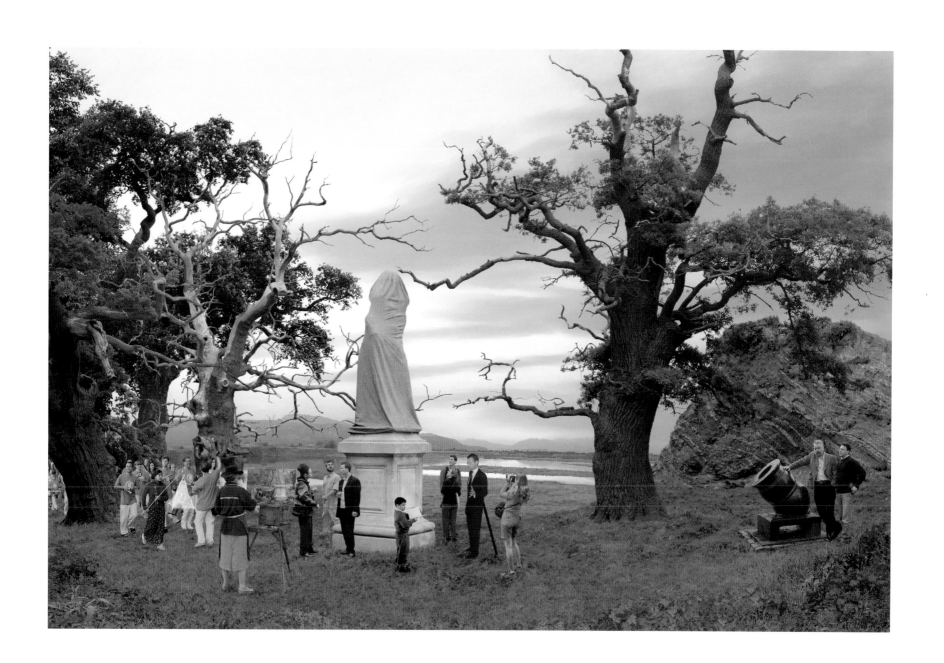

Dreamers

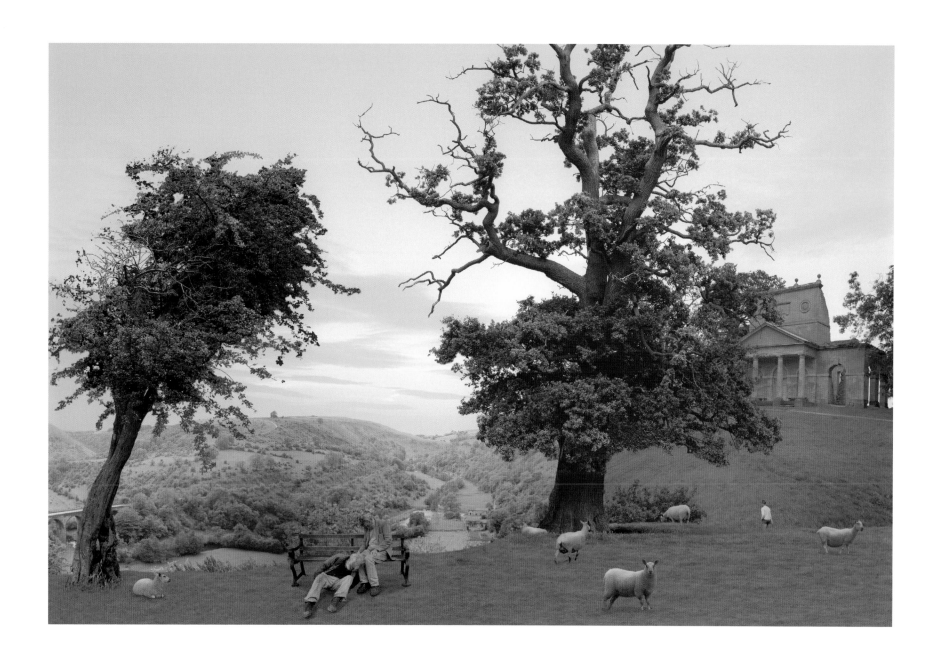

Deluge

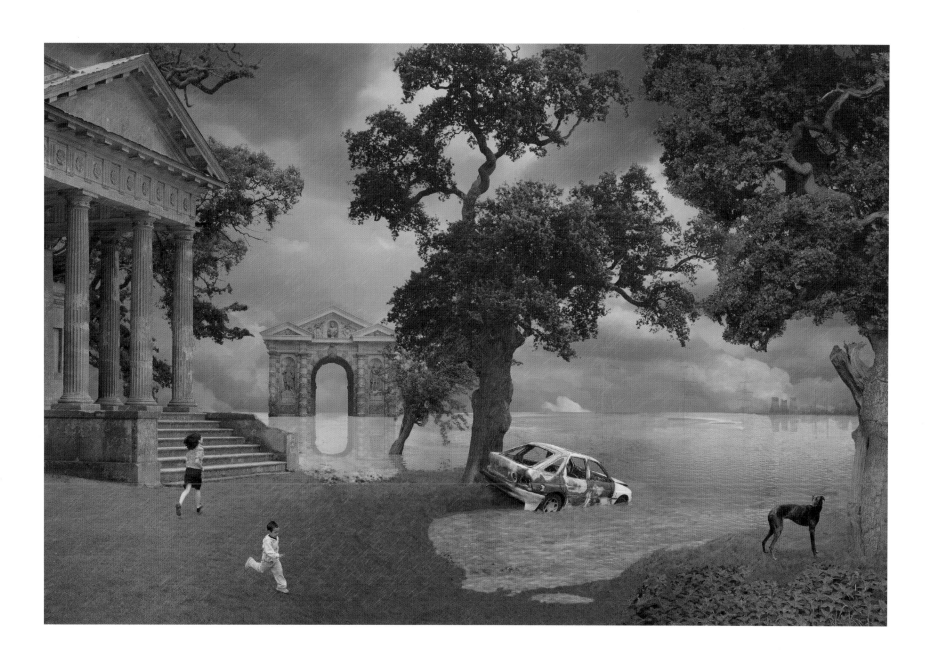

Pasturelands

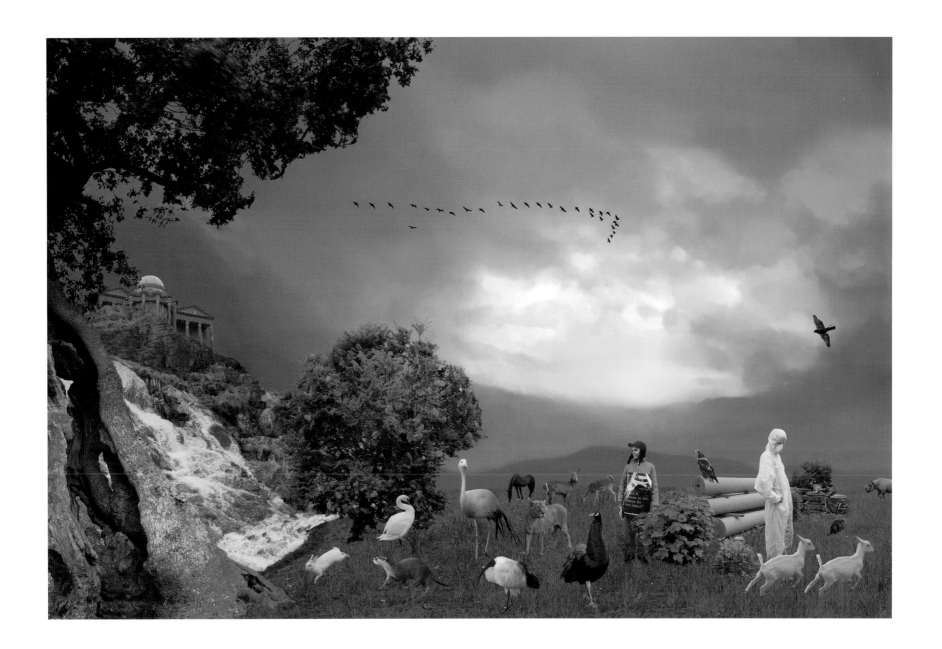

Brigands

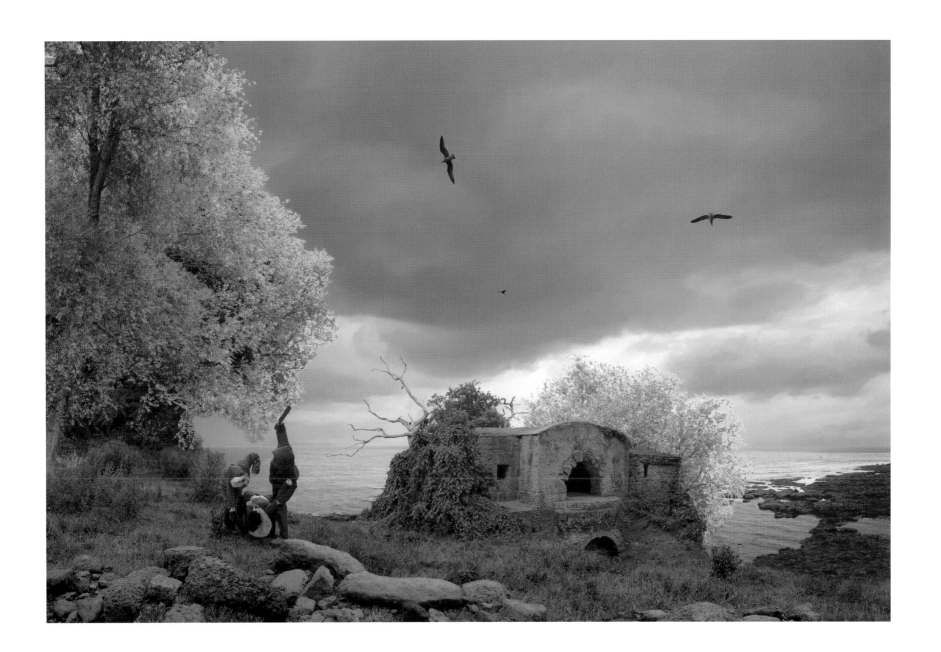

High Ground

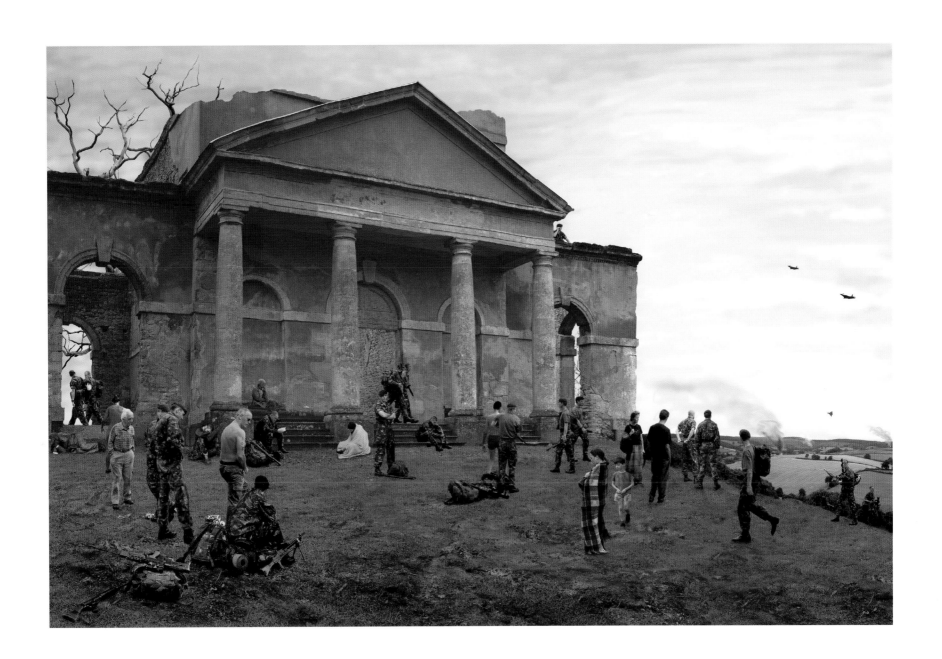

Farmer

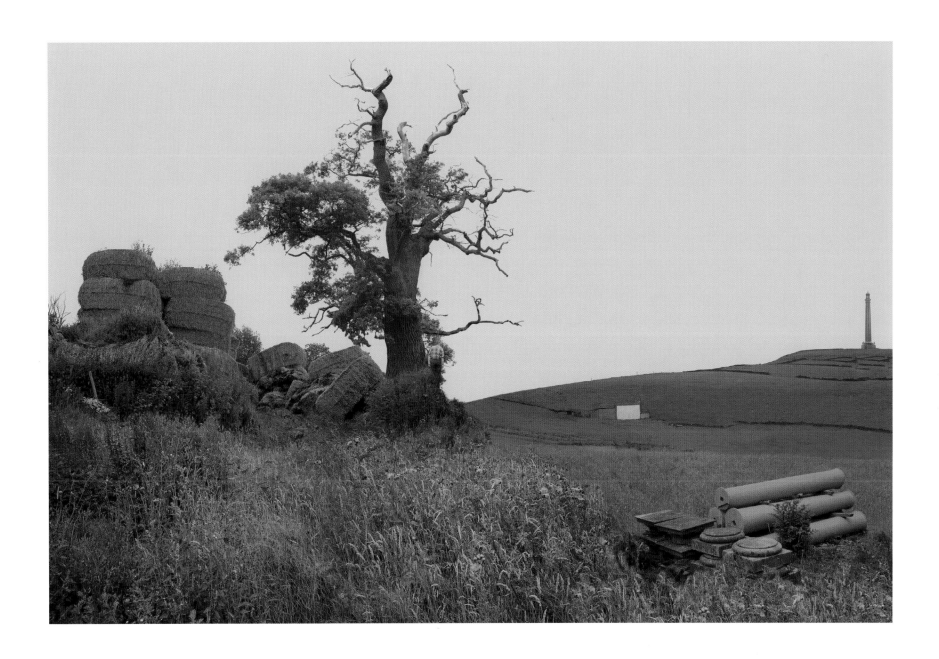

Harvest

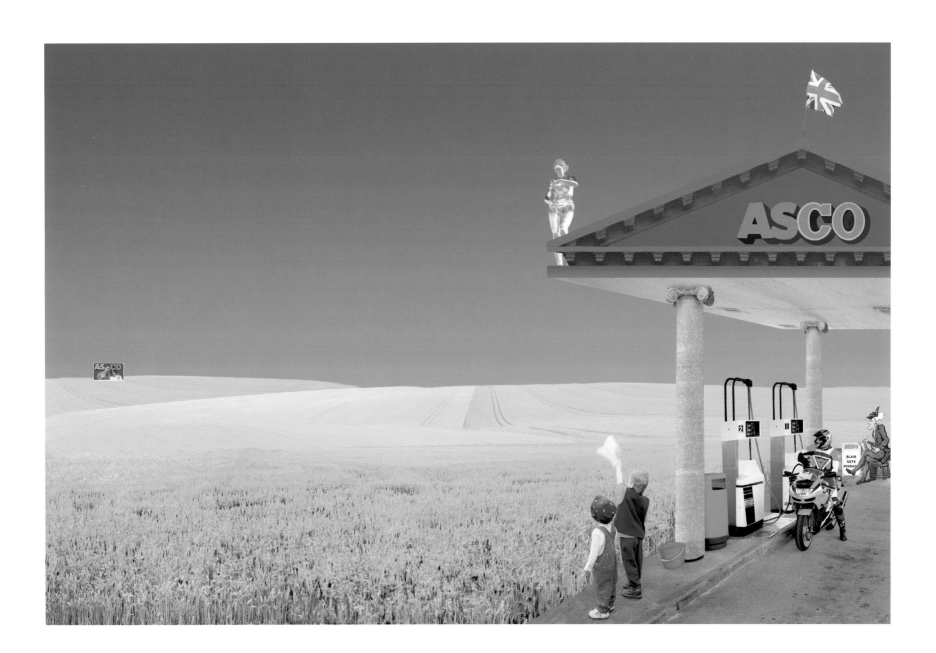

Mixed Messages:
Disordering Documentary

Mark Durden

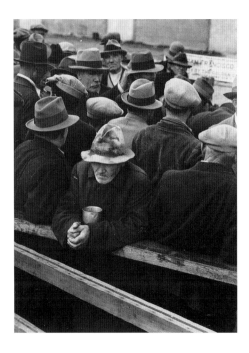

White Angel Bread Line, San Francisco 1933
Dorothea Lange.
Copyright the Dorothea Lange Collection,
Oakland Museum of California, City of Oakland. Gift of Paul S. Taylor

Most current photographers merely reflect the 'objective' misery of the human condition - a wretchedness which has apparently become a positive object of perverse desire for so many aesthetes and image racketeers. Just as there is no primitive tribe which does not have its anthropologist, soon there won't be a homeless person sleeping curled up amid his filth who doesn't find a photographer leaping out of the urban jungle to capture on film the eternal sleep of the pauper.[1]
Jean Baudrillard

Jean Baudrillard's damning attack on the documentary photographer is perhaps a useful way to begin to think about the implications of John Goto's series, *Gilt City*: full figure 'portraits' of outsider urban types - street entertainers, homeless people, drug dealers, hawkers. Many of these colourful characters are set against the blank 'grey' corporate architecture of late capitalism, the generic faceless façades of the banking worlds of the over developed West; façades which, in a comic version of modernity, sometimes reflect the rushing masses of suited business types.

What distances Goto from documentary's tradition of picturing misery and wretchedness is his recourse to a staged tableau photography and the use of digital compositing. Friends and associates of the artist - including critics, curators, students,

neighbours - are dressed and posed by the artist in a studio setting. The portrait is then digitally mapped onto particular spaces in the City of London's financial district. As a result there is neither filth nor degradation in his pictures. Indeed, *Gilt City* might be seen to continue the ethical disavowal of documentary photography which characterises the work of Jeff Wall. Only Wall's pictures are bereft of the parody and playfulness of Goto's tableaux. And while Wall will meticulously mime a documentary look, Goto never disguises his pictures' artifice. Instead, artifice and theatre is flagged up in *Gilt City*.

Goto uses the codes of documentary to frame and identify his subjects. Playing out permutations of difference and otherness, his photographic theatre, however, deliberately upsets the familiar patterns of viewing such documentary-type subject matter. The pictures are discordant in this respect. For all the immediate signs and signals of alterity, the people who populate *Gilt City* fail to cohere as distant and distinct from its middle-class audience. As a result, his pictures resist and oppose the simple liberal humanist reflex of pity. They are also bereft of the affective dimension which tends to be associated with documentary practice: the pathos accrued by the photo as index and that sense of the residue of the emotionally charged interaction - however respectful, however abusive - between subject and photographer.

Details in Goto's staged and knowing tableaux function as signs whose connotations very often flout and undermine the codes and conventions, the rhetoric, ordinarily associated with documentary. There is an attention to signifying details: to do with the style of clothing, incongruously often fashionable and trendy - evident through all the designer labels and logos - and the accompanying objects, which are often just as anomalous, like the can of Beck's in his 'portrait' of the urinating man, for example: Beck's, renowned for its sponsorship of contemporary art, being more readily associated with the YBA crowds than the street drinker. The man also carries a copy of Bill Jordan's book *A Theory of Poverty and Social Exclusion*, implying an improbable self-reflective and theorised view of his own position. All this suggests a conscious playing with the codes and signs used to judge, identify and 'label' people.

If many of his subjects accord with the idea of the generic outsider type, and many are iconographically familiar as postures and stances drawn from the history of art and the history of photography, they also carry a sense of character and presence to do with the physical particularities of those who pose for him. The fiction and theatre of this series of contrived and knowing poses tends to be disrupted and countered by the facticity of individualising corporeal details: particularly evident in the suited but shirtless figure in *Bacchant*: the body's emaciated state, the detail of the intravenous plug attached to his stomach, the scarring on the skin round his jaw.

In *Beggar* the posture of the subject suggests something more than the act of begging. There is a saintliness to the kneeling figure. That he begs using a McDonald's drinking cup, whose golden arches echo the top of St Paul's which is reflected in the background, adds to the picture's contradictory spiritual resonance. Of course this is all heavily parodic, involving both a perverse reversal of value in a materialistic icon for global fast food consumption and a perverse variant of the idea of the saintliness of the deserving poor. McDonald's is here a very incongruous sign, undercutting the religiosity of the El Greco-like begging figure. The picture also parodies the documentary trope of giving the poor spiritual and saintly import - Goto's *Beggar* echoes Dorothea Lange's photograph *White Angel Bread Line*, which shows a lone elderly figure, set apart from the hungry crowds, his hands tightly held together around his cup in an attitude that resembles prayer.

McDonald's and Coca Cola served as occasional interrupting signs amidst the poverty in Boris Mikhailov's post-Soviet documentary, *Case History*. Mikhailov foregrounded the unethical exchange which forms the basis of his pictures. He paid his subjects, drawn from the 'new homeless' of his home town in the Ukraine, to undress and pose for him. Underlying his portraits is a warped version of Western capitalist exchange as his 'bought' impoverished subjects strip off and parade their nakedness to him and subsequently to the West. Goto's *Naked*, in which a rather androgynous male figure hurriedly takes off his pants on the steps of the portals to a big bank, seems a clear parody of Mikhailov.

Goto's reference to fast food and homelessness in *Beggar* also alludes to Philip-Lorca diCorcia's series *Hollywood*, which sets a number of its portraits of male drifters and prostitutes against the glowing signs of fast food eateries; suggesting corollaries between fast food consumption and the commodification of its subjects. Their availability for purchase was further underscored by diCorcia's disclosure of the amount of money he paid each of his subjects to pose for him. In Goto's picture of charity, in which the subject invites passersby to give to the needy through a cup which bears the sign of the global greed of a multinational, we have a succinct reminder of the bigger problems of economic exchange and inequities - made evident in both diCorcia's and Mikhailov's documentary-based projects.

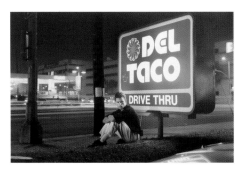

Ralph Smith; 21 years old; Ft. Lauderdale, Florida; $25, 1990-1992
Philip-Lorca diCorcia.

Copyright Philip-Lorca diCorcia.

Courtesy Pace/MacGill Gallery, New York

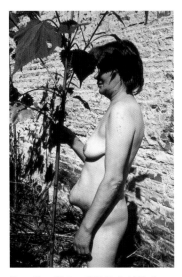

From *Case History* 1999 Boris Mikhailov.

Copyright the artist.

Courtesy The Photographers' Gallery, London

Many of Goto's pictures play on an unexpected disparity of codes - a joining of sign systems that seem inappropriate. The stylishness of his subjects rubs up against our assumptions of alterity. Much as they may appear to stand apart in Goto's tableaux, such figures are partly assimilated by the globalism of commodity culture.

In *Bucketman*, one of the most theatrical and comic, the male does a headstand with his head in a semi-transparent bucket. Goto plays with associations here. The performer's body position is emblematic of the artist's satirical perspective on the world. The inversion of the figure corresponds with the inversions of values which recur in *Gilt City*. The performance of this street entertainer also points to a condition of wilful blindness, of putting your head in the sand. One might then ask: who is this critical commentary addressed to? It certainly is not this street performer. Instead, Goto seems to direct his satire at the liberal humanist viewer. The punning title of the series draws attention to the guilty unease with which the middle-class tend to view such outsider types, misfits, and marginals. It also might be seen to suggest the atrophy of social conscience (guilt) by money (gilt) and free market ideology. So, in contrast to much documentary, this is not about trying to speak for the socially disempowered, but instead uses signs of difference - albeit skewed and

reconfigured - to say something about the value systems which keep these types in their place, on the streets, begging, dealing, hawking, performing etc.

Goto's *Ecoist* is a hybrid figure. Sporting a briefcase and umbrella, she represents the outsider as insider, the subversive mutating into a business type. Alternative causes have now become capitalist concerns. The stylishness and modishness of Goto's 'portrait' also links up with the readiness with which recent colour documentary can glamorise and idealise outsider types. Much as his pictures play with difference and outsiderness, as such a transitional and modish figure succinctly demonstrates, difference is now increasingly blurred and indeterminate, like the reflections on the polished slick surfaces of the postmodern space, which now provides the Ecoist's environment.

Many of the characters in Goto's tableaux provide a parodic mimesis of the activities of people within the city. *Tout*, for example, does not deal in contraband goods, instead what he is selling, as revealed when he flashes open his coat, are the company logos for companies listed in the FTSE 100. Trading on the stock exchange is replayed in the form of the low trade of the street hawker; both, Goto implies, are just as shady. Similarly *Bullfighter* and *Bear Trainer*, offer a comic allusion to trading on the stock

exchange - only reversing the relationship between bull and bear traders, the bull a mere calf and the bear ferocious and threatening its tamer. Appropriately and inevitably the artist also includes himself in *Gilt City*. In *Hawker*, Goto appears as a dodgy guy on the street corner attempting to flog one of his pictures. *Hawker* finds its counterpart in the parodic portrait of the art *Collector*, here pictured as an obsessive scavenger, clutching a batch of newspapers and wearing a stylish pair of Converse sneakers.

Security is arguably Goto's most contentious image, playing with white anxieties and hang-ups about race and representation. Here a white male with face blacked up, guards the glass portals to some financial building. The figure highlights Goto's white and predominantly male repertoire of characters. That he also looks like a military type, an army irregular, is important. Much as he stands to defend the building, at the same time he also can be seen to evoke a threat, represent a potential rogue force. The picture itself is formally constructed to highlight division and opposition - brought out through the approaching figure of a suited young male who can be seen reflected in the glass doors. The burly security guard serves to block his entrance; a separation further brought out through the way the X formed by the door handles serves as a barring

cross over the reflected figure. *Security* thus serves to raise questions about all sorts of exclusions and divisions and rebounds back onto the series as a whole, in the way the bouncer figure serves to physically enact a resistance to the viewer's identification.

In *Writer*, the slogan seems more like a corporate (or nation state's) mission statement than a challenge to the building the figure is vandalising: 'A State of War A World of Opportunity'. Made in response to the second Gulf War, a war very much driven by the US's desire to control Iraq's oil reserves, the resonances of such a message are quite clear. In *Writer*, protest and opposition is nothing more than endorsement. Twisting and distorting signs, such a picture points out the coextensive relationship between an imposing neo-classical corporate edifice and the subject who spray paints it.

Much as the series *Gilt City* might suggest the idea of resistance associated with its parade of street types, all potentially symbolic of revolutionary and counter cultural forces, the overriding message is about their ultimate ineffectuality. Documentary is not only disordered here, but its ideals are radically shaken. Capitalism, in Goto's pictures, becomes a pervasive monolithic force, readily assimilating and commodifying any signs of subversion or deviance.

At the same time, the work itself is nevertheless clearly positioned as resistant, using irony, satire and farce as oppositional forms, but from within not from without.

Documentary traditionally functioned to engage with injustices and inequities in order to provoke active responses. The current vogue for documentary in contemporary art has entailed a documentary *in extremis*, often consciously unethical and sensational, and often aggressive and shocking in its subject matter: reducing human misery to an object of consumption. As a result it has lost much of its political meaning and import. Goto, rooted in a tradition of satire and irony, revisits documentary's history but keeps his distance from it. He borrows and distorts the codes of documentary in order to portray contemporary capitalist concerns and tap into liberal humanist guilt, desires and fears.

1. Jean Baudrillard, 'It is the Object that Thinks us' in Peter Weibel, *Jean Baudrillard Photographies 1985-1998*, Graz: Hatje Cantz Publishers, 1999, p.151.

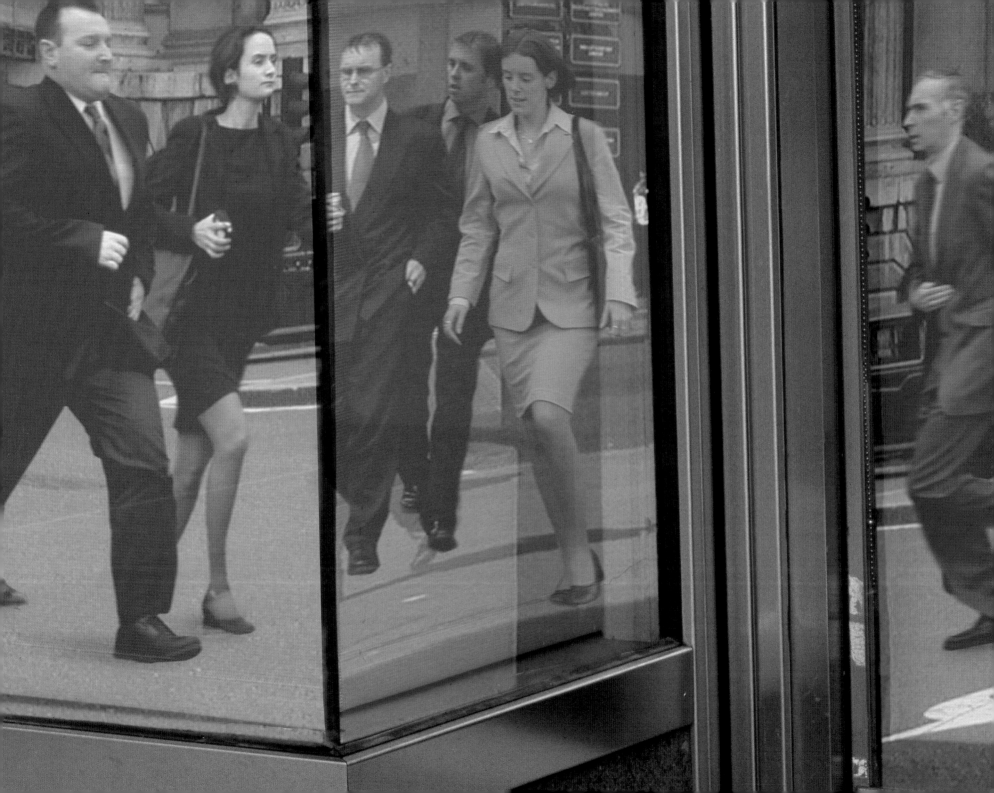

Gilt City

previous page
Collector (detail)

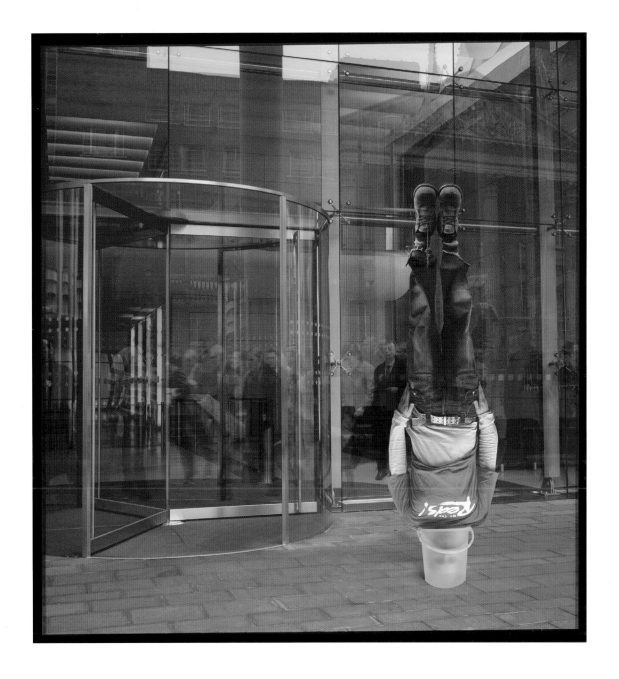

Bucketman

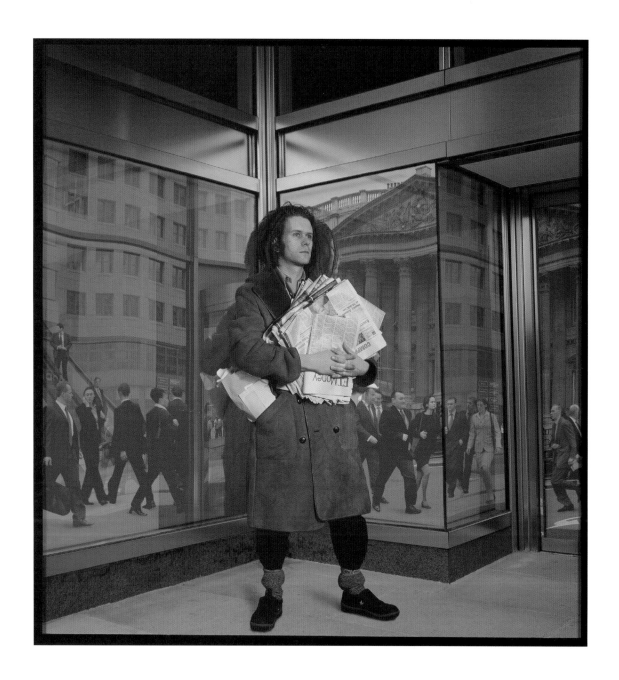

Collector

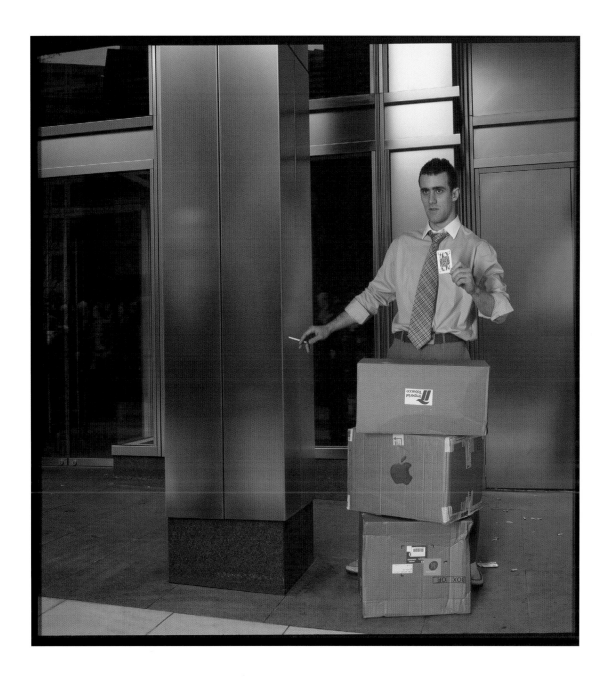

Cardsharp

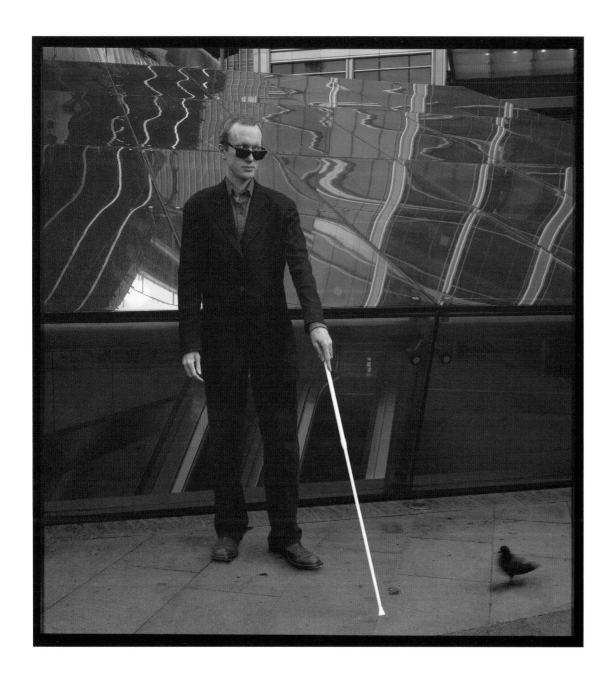

Blindman

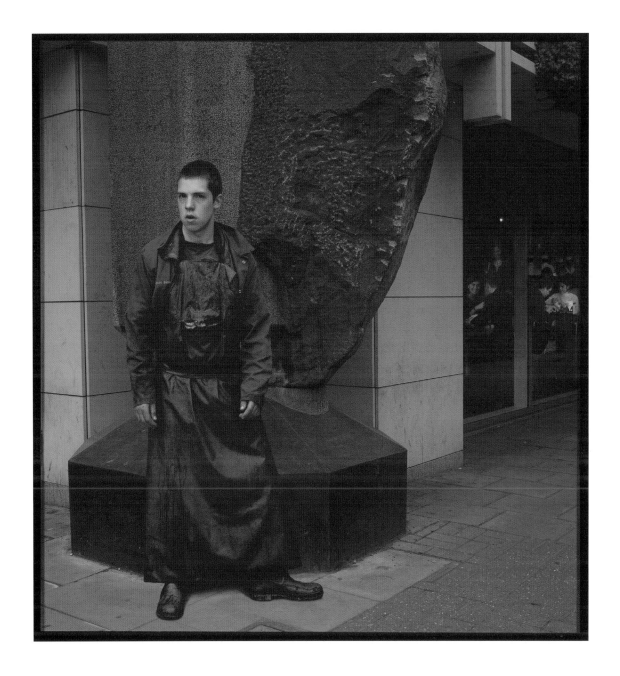

Worker

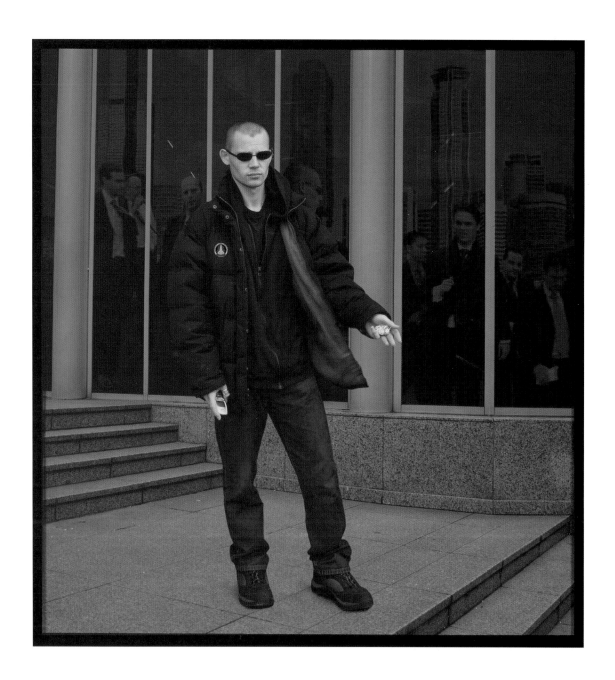

Dealer

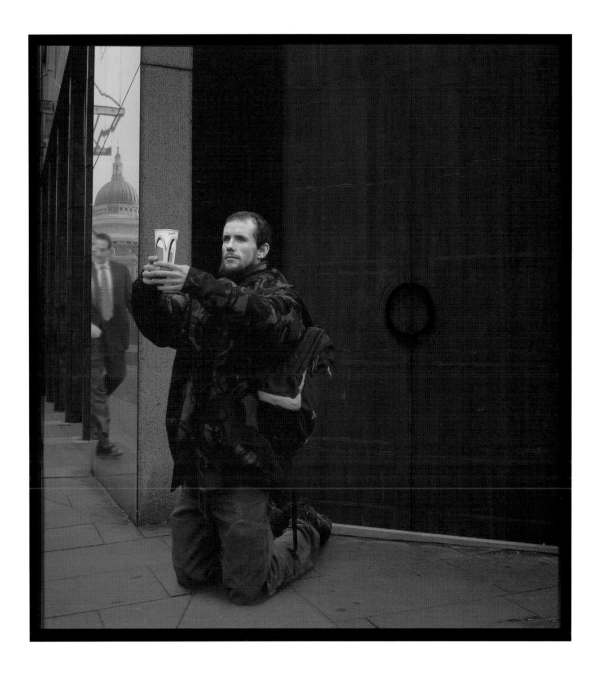

Beggar

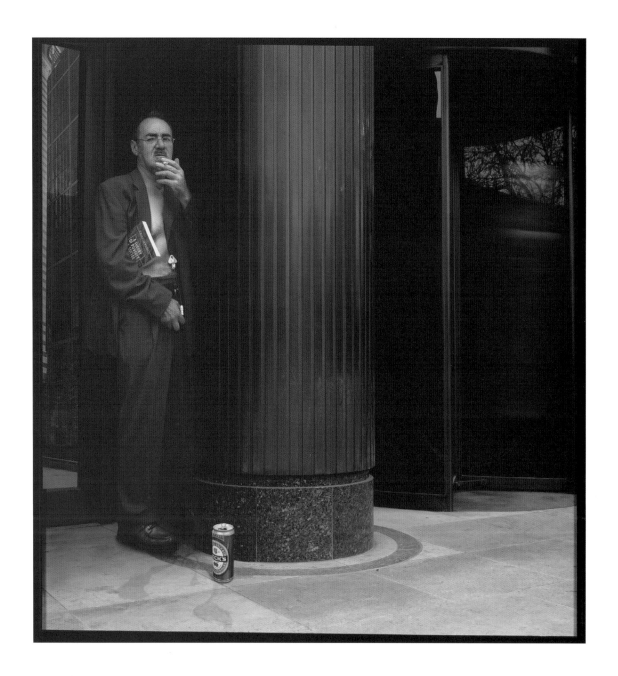

Bacchant

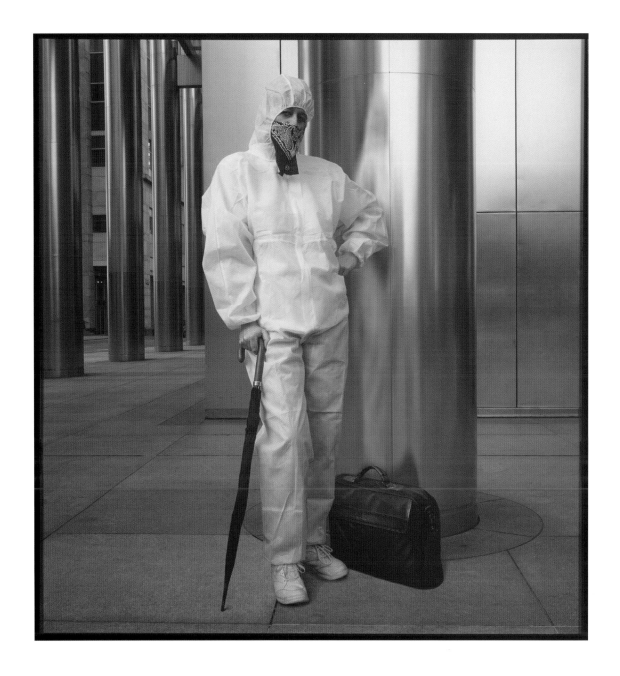

Ecoist

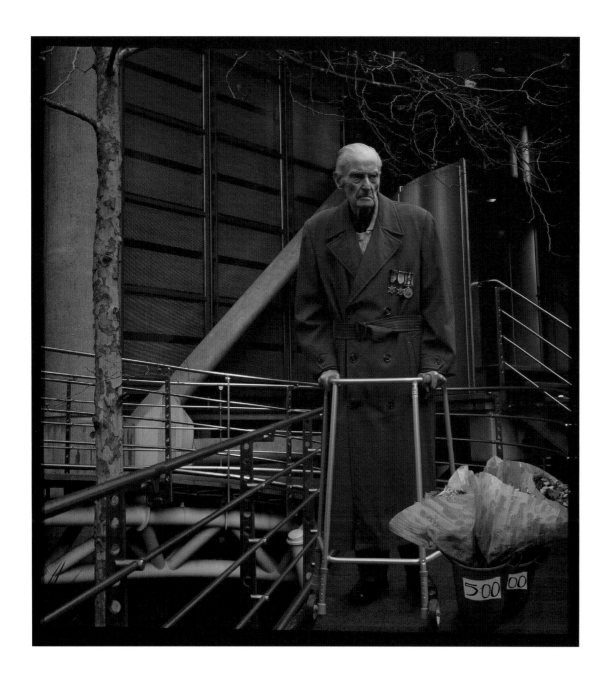

Flower Seller

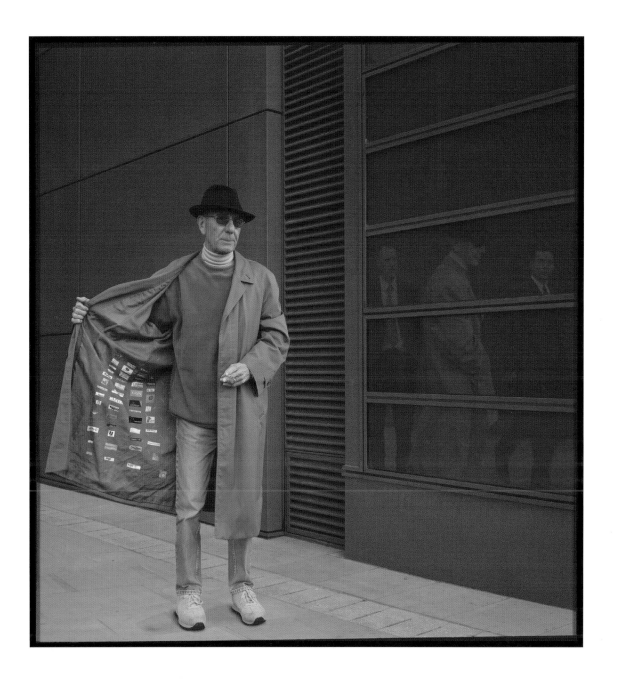

Tout

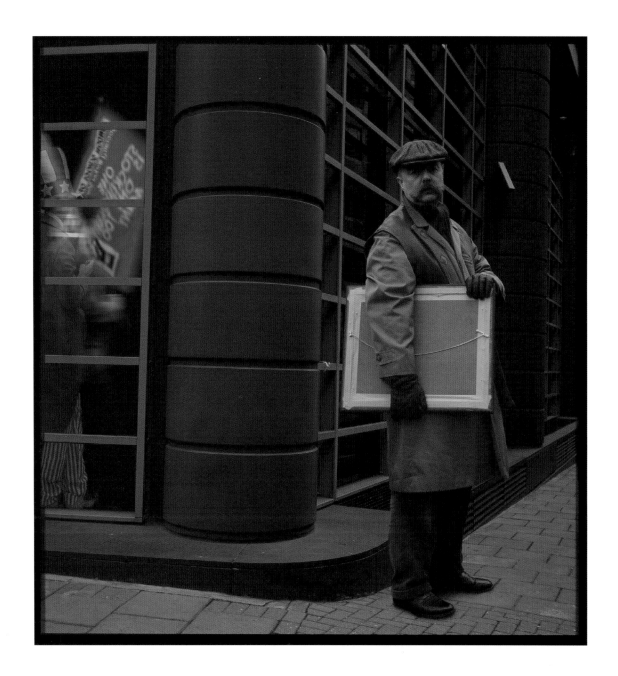

Hawker

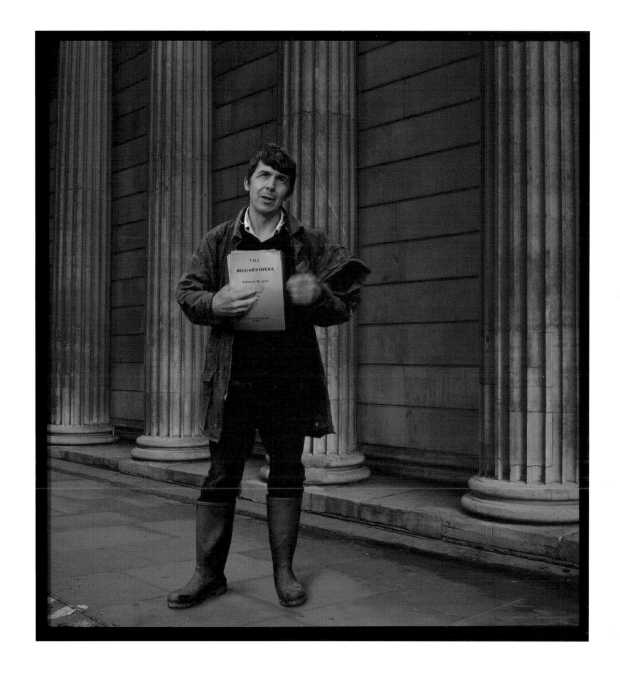

Busker

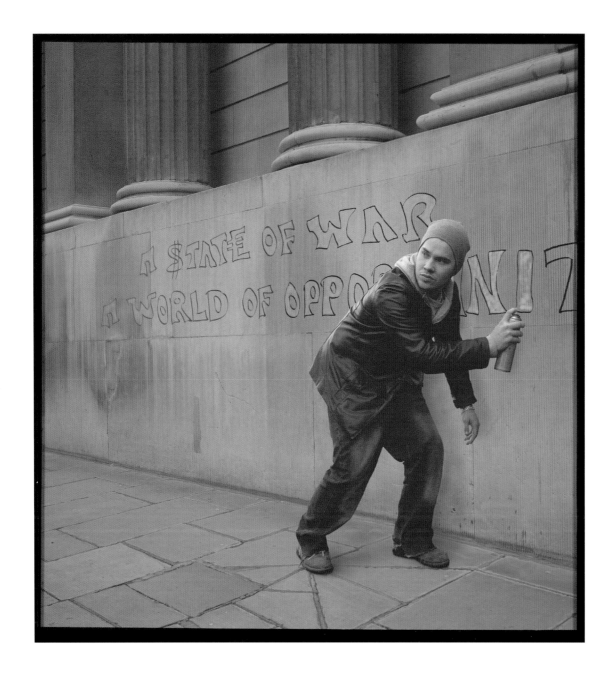

Writer

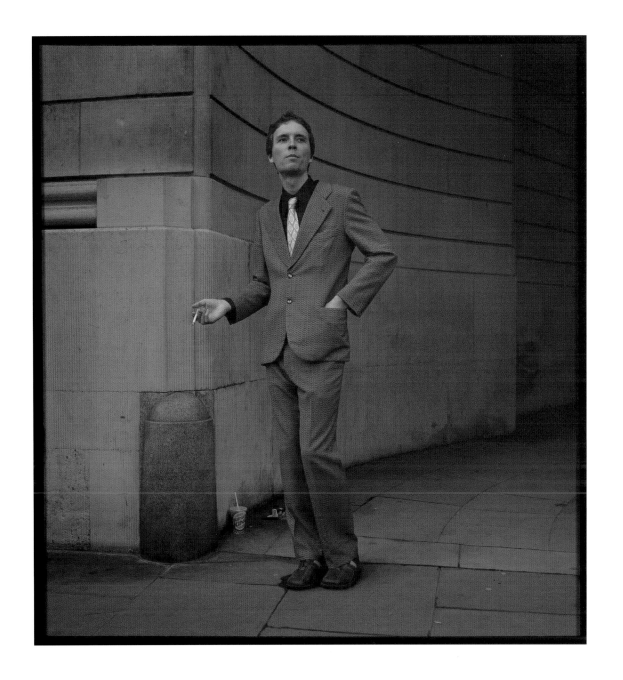

Hustler

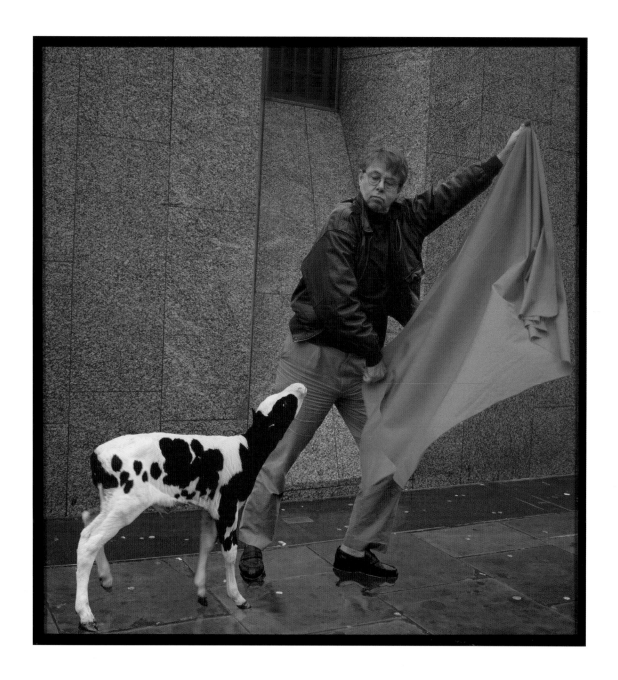

Bullfighter

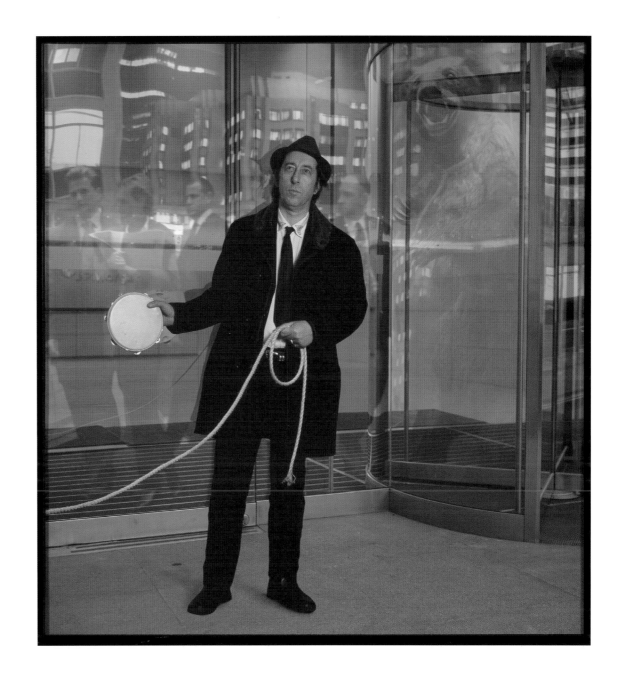

Bear Tamer

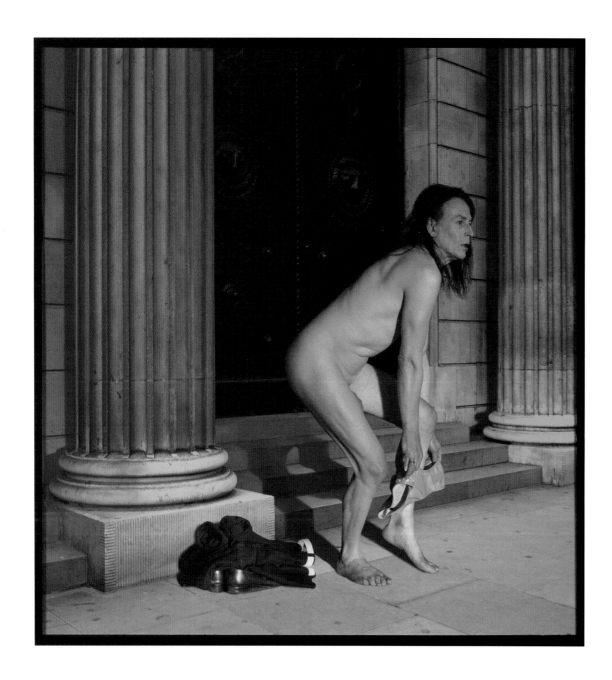

Naked

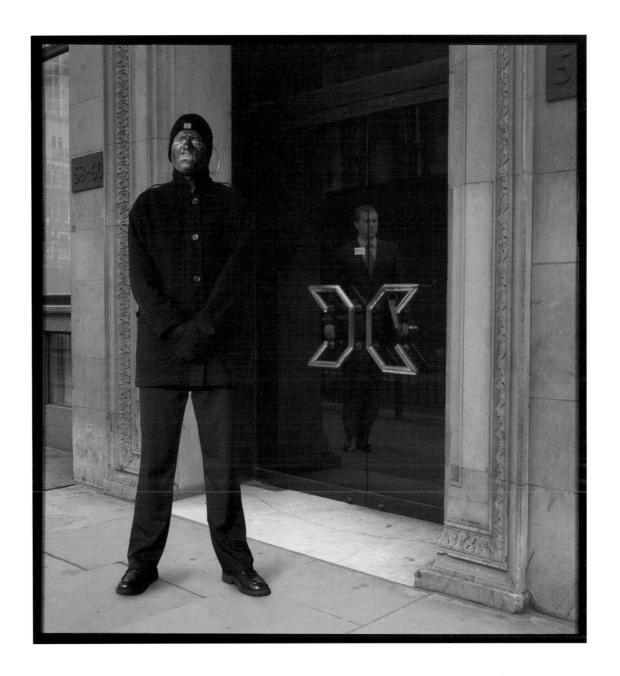

Security

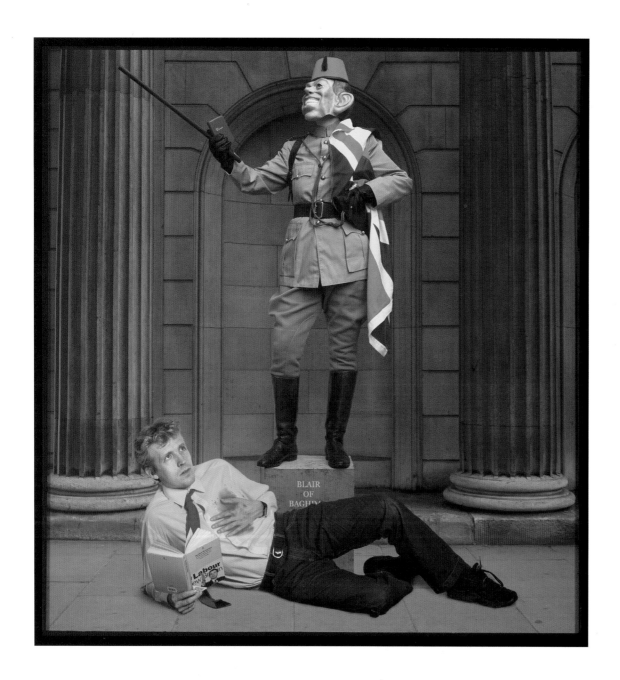

BLAIR
OF
BAGHDAD

Living Sculpture

This book has been published in conjunction with the
exhibition organised by the Djanogly Art Gallery

Ukadia **Recent Photo-Digital Works by John Goto**
6 September – 19 October 2003

ISBN 1 900809 16 8

John Goto's work is represented by
Andrew Mummery Gallery, London
Email: info@andrewmummery.com
www.andrewmummery.com

Design by David Bickerstaff and John Goto
Print by Pyramid Press, Print and Design Limited, Nottingham
in an addition of 1,000

Djanogly Art Gallery
Lakeside Arts Centre
University Park
Nottingham NG7 2RD

Catalogue of Reproduced Works

Height precedes width

Dimensions in centimetres

Capital Arcade
1997 – 1999

Pigment inkjet prints on cotton paper
edition of three

Welcome to Capital Arcade	110 x 157 cm
Unit 1 Capital Arcade	110 x 157 cm
Unit 2 Capital Arcade	110 x 157 cm
Unit 3 Capital Arcade	110 x 157 cm
Unit 4 Capital Arcade	110 x 157 cm
Unit 5 Capital Arcade	110 x 157 cm
Unit 6 Capital Arcade	110 x 157 cm
Unit 7 Capital Arcade	110 x 157 cm
Unit 8 Capital Arcade	110 x 157 cm
Unit 9 Capital Arcade	110 x 157 cm

High Summer
2000-2001

Pigment inkjet prints on cotton paper
edition of three

Eco Warriors	61.5 x 92.5 cm
Hunters	61.5 x 92.5 cm
Dancer	55 x 82 cm
Movie	55 x 82 cm
Society	72.5 x 110 cm
Sporta	63 x 95 cm
Beach	72.5 x 110 cm
Plinth	49.5 x 74 cm
Dreamers	49.5 x 74 cm
Deluge	60 x 90 cm
Pasturelands	63 x 95 cm
Brigands	60 x 90 cm
High Ground	60 x 90 cm
Farmer	47 x 71 cm
Harvest	60 x 90 cm

Gilt City
2002 – 2003

Pigment inkjet prints on cotton paper
edition of three

Bucketman	79 x 74 cm
Collector	79 x 74 cm
Cardsharp	79 x 74 cm
Blindman	79 x 74 cm
Worker	79 x 74 cm
Dealer	79 x 74 cm
Beggar	79 x 74 cm
Bacchant	79 x 74 cm
Ecoist	79 x 74 cm
Flower Seller	79 x 74 cm
Tout	79 x 74 cm
Hawker	79 x 74 cm
Busker	79 x 74 cm
Writer	79 x 74 cm
Hustler	79 x 74 cm
Bullfighter	79 x 74 cm
Bear Tamer	79 x 74 cm
Naked	79 x 74 cm
Security	79 x 74 cm
Living Sculpture	79 x 74 cm

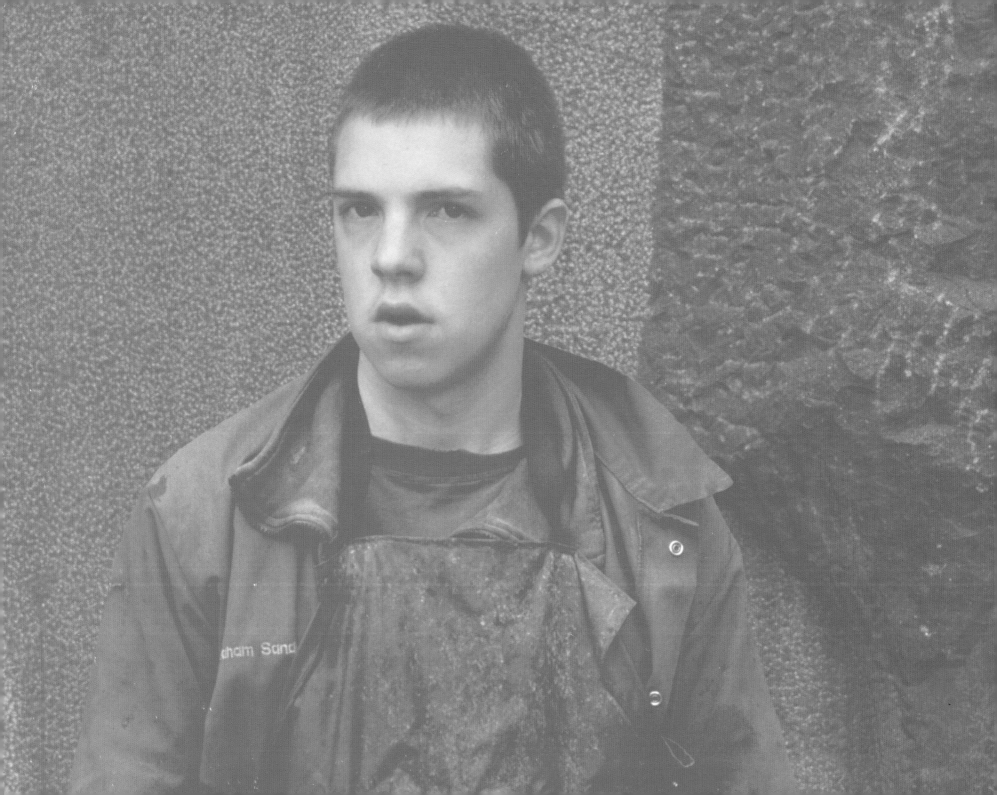